ROYAL ACADEMY ILLUSTRATED 2004

'Drawing is the true test of art'
Jean-Auguste-Dominique Ingres (1780–1867)

ROYAL ACADEMY ILLUSTRATED 2004

A selection from the
236th Summer Exhibition

Edited by Allen Jones RA,
with David Hockney RA

Royal
Academy
of Arts

SPONSORED BY

ATKEARNEY

Contents

Sponsor's Preface

This year's Summer Exhibition will be a particularly memorable and special occasion for A.T. Kearney, as it is the final year of our sponsorship of the show. Over the past six years, we, our clients and friends have enjoyed the vast display of creativity and diversity that the Summer Exhibition always delivers.

A.T. Kearney has a long-standing history of commitment to the arts and believes strongly in the value of creativity in everyday and business life. In the same way that an artist presents the observer with a new perspective on a familiar object or issue, we seek to help our clients view their businesses in a different light. We strive to be imaginative, bold and pragmatic, required qualities in those who wish to be 'artists in business'.

Our own art programme includes an annual 'Art in the Office' exhibition, now in its ninth year, and 'Portraits of Business', a unique artistic initiative which ties in with our sponsorship of the Summer Exhibition. This involves commissioning Royal Academicians to create their interpretations of leading multinational companies, capturing the essence of these businesses in a visual form. You will see this year's portraits – of ICI by Gus Cummins RA, and Orange by Christopher Le Brun RA – hanging in the Vestibule.

We have greatly enjoyed our relationship with the Royal Academy of Arts over the years, and the opportunities it has brought us to strengthen further the links between art and business. We wish them every success for this and future exhibitions.

Duncan Craig
Managing Director, UK and South Africa
ATKEARNEY

A.T. Kearney is one of the leading management consulting firms in the world. Our people combine industry experience with creative insight to deliver rapid, sustainable results as part of a team with our clients.

The art critics, who tediously complain that the Royal Academy's Summer Exhibition is as changeless as the man in the moon, may be caught short by some of the ways in which this show differs from last year's. This is in itself evidence of the Academy's continuing desire to move with the times without doing injury to time-honoured traditions.

To begin with, the colour of the walls has changed. You'll also be struck by the sheer number of drawings. These somehow define the character of the entire exhibition, and are there because artists submitting work – Members as well as non-Members – were encouraged from the beginning to send them in. So many of such good quality arrived that two entire galleries have been devoted to them more or less exclusively.

This emphasis is unprecedented but entirely appropriate in an exhibition at the Royal Academy, whose Schools have encouraged the art of drawing from the institution's beginning in 1768. What's more, at times when the discipline was being questioned or ignored elsewhere, the Academy stood alone in acknowledging its importance for every kind of artistic activity.

What gives the drawings on show here additional interest is the appearance among them of works by people who are not artists but who use drawing in their daily professional lives. Unconcerned with aesthetics, or even with training the eye and hand, they use drawing to explain, record and to aid understanding. Allen Jones, one of the co-ordinators of this year's Summer Exhibition, is excited by their contribution. He wanted to show drawings that are 'as near as possible to the original creative impulse, to the original thought. I felt that we needed to recognise drawing not exclusively as fine art, but as a form of communication. Next to speaking and singing, drawing must be the most ancient form of communication of all.'

The result is the truly fascinating display in Gallery VI. 'It includes drawings by two Nobel prizewinners, a film director, composers, fashion designers, doctors, dancers, and the manager of the England rugby team,' says Jones. 'These appear with drawings in a wide variety of media by professional artists, Members and non-Members alike. They were made either as works of art in their own right or as sketches and studies. You'd be hard put to find anything like this impressive collection of drawings anywhere.'

The Summer Exhibition is unique. It also remains as necessary as ever. It's a rare and necessary reminder that art is not and has never been monolithic. It has many different makers and as many different publics. This show is the most varied, and therefore the most informative, group exhibition staged anywhere in the world.

Part of the exhibition, although outside the building in the Annenberg Courtyard, is a group of three large sculptures, two of them unusual examples of the work of Lynn Chadwick, a Senior Academician who died last year. The third is *Holy Island*, a collaborative work by Bill Woodrow and Richard Deacon.

Gallery 1

There's a hint of subversion in Anthony Green's description of the gallery he's hung. 'It delivers a challenge to our progressive friends,' he says with a grin, 'while reassuring regular visitors that the Summer Exhibition is back to its time-honoured form. They'll start to be shocked only when they leave this room and move into the next.'

Certainly most of the artists here are such popular perennials as Fred Cuming (look at *Etna from Taormina* to see why) and Ken Howard. Howard demonstrates his versatility by including a painting of a rugby match among views of Venice and the interior of one of his English studios.

Two of the three painter-Members whose deaths have sadly occurred since the last Summer Exhibition – Colin Hayes and Patrick Procktor – are given traditional memorial displays here. Almost everyone else represented in this gallery is an RA. They include Olwyn Bowey, David Tindle and Mick Rooney, whose *Susannah and the Elders* leads Green to remark that 'Carel Weight's shadow hangs over this gallery'. That's surely an exaggeration, since Mary Fedden and William Bowyer are also present, together with Philip Sutton's sizzlingly coloured pictures which have no room for enigmatic atmospheres, similar to Weight's or not.

Pausing to pay compliments to Neil Jeffries and the highly individualistic Jeffery Camp, between whose unconventionally shaped pictures a small, wall-mounted sculpture by Brian Falconbridge is interposed, Green points admiringly to a drawing by Ben Levene, 'the superstar of the Slade in the late 1950s', a toughly worked landscape in pencil and ink. Levene has two paintings here too, one of them entitled *Autumn SE London, 2003*.

The sculpture in this gallery is by Ralph Brown and James Butler, the latter perhaps best known for his military memorials (he was one of the sculpture selectors for this year's exhibition). A work of sculpture in less traditional materials is John Patrick Humphreys's *Portrait of Leonard McComb*, made of glass fibre meticulously painted in acrylics. If you know McComb you'll recognise him instantly, though you may be unsettled by the elongation of his head. It's as though Ron Mueck had produced this extraordinary piece of obsessive realism having unwittingly put on the wrong spectacles.

David Tindle RA
Window with Pigeon
Egg tempera
73 × 59 cm

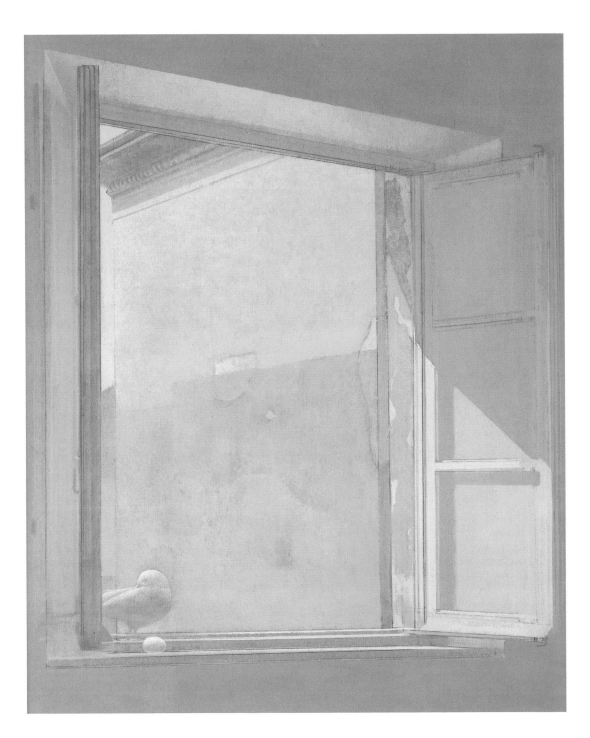

The late Patrick Procktor RA
Peter in Luxor
Oil
57 × 67 cm

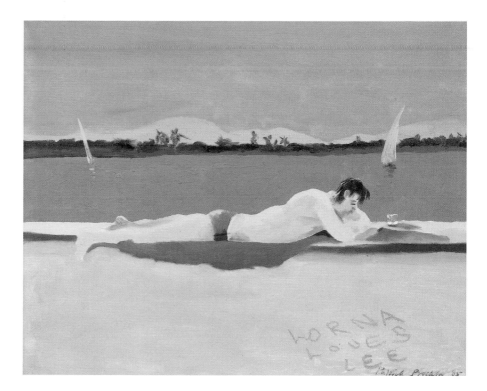

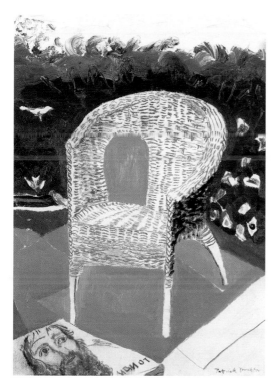

The late Patrick Procktor RA
Wicker Chair
Oil and charcoal
66 × 45 cm

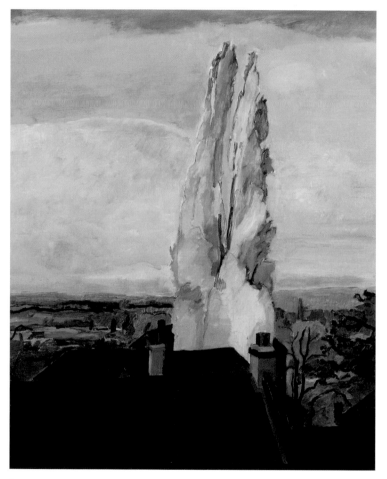

Ben Levene RA
Autumn SE London, 2003
Oil
47 × 45 cm

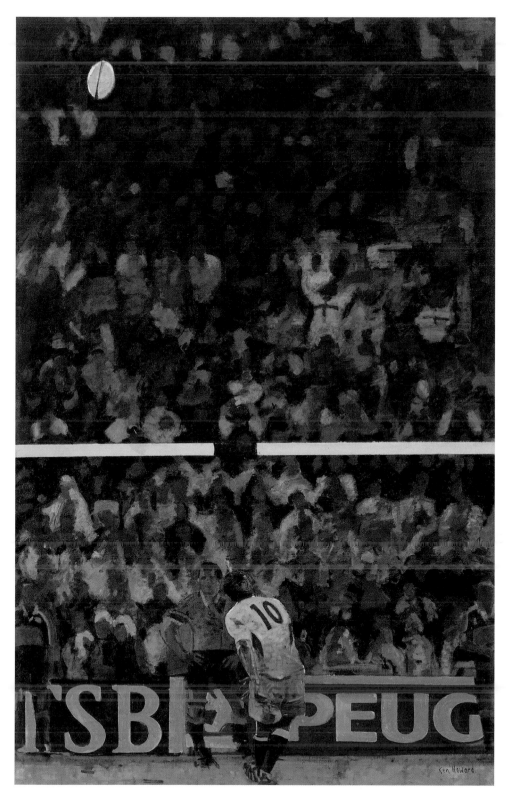

Ken Howard RA
Wilko
Oil
180 × 112 cm

Frederick Cuming RA
Etna from Taormina
Oil
90 × 90 cm

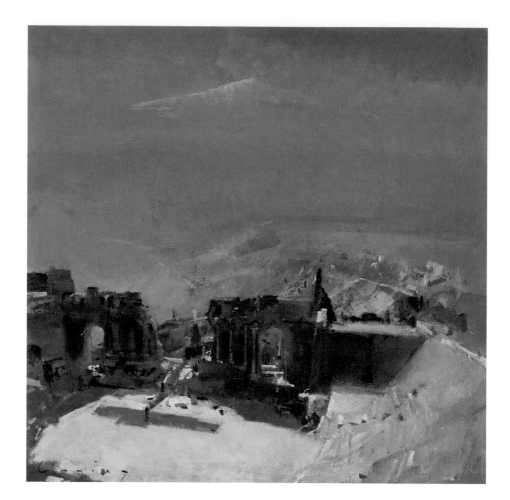

Ralph Brown RA
Clochard
Bronze
H 40 cm

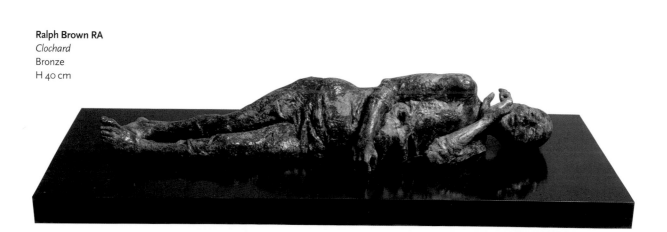

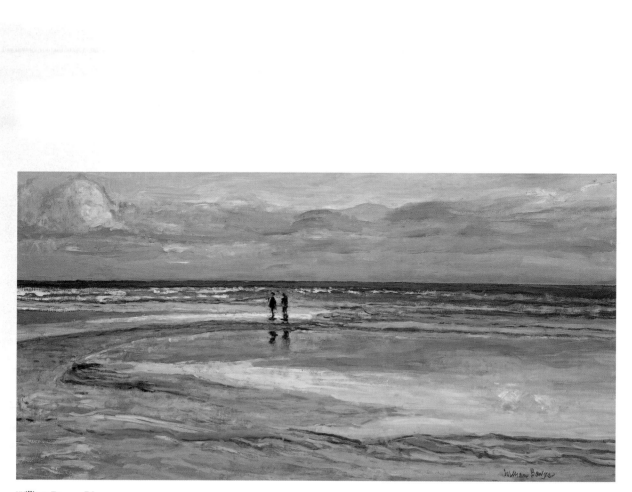

William Bowyer RA
The Beach, Walberswick
Oil
52 × 100 cm

Jean Cooke RA
Fire in Summer
Acrylic
121 × 90 cm

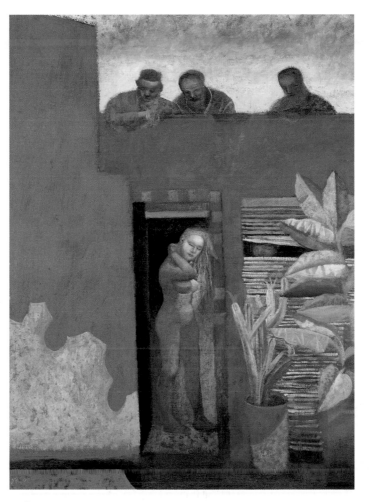

Mick Rooney RA
Susannah and the Elders
Oil
58 × 43 cm

Olwyn Bowey RA
Artichokes
Oil
74 × 62 cm

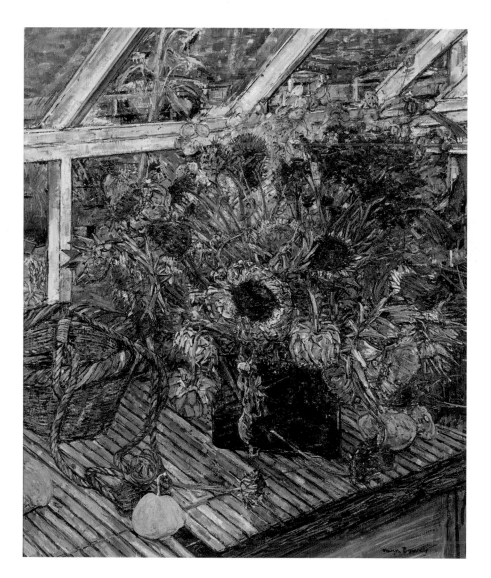

Philip Sutton RA
Once Upon a Time!
Oil
173 × 173 cm

Gallery II

The end wall of Gallery II is completely taken up with what John Hoyland, Professor of Painting at the Academy Schools, describes as 'Terry Frost's *magnum opus*. He made it last year, when he knew he was dying. It consists of a painting with 28 separate elements or images in it, as well as cubes in various colours and sizes arranged on the floor in front.'

It's because of Frost's death that he's been given a prominent display here, and it includes 'this big composition because he very much wanted it to be shown at the RA', adds Hoyland, who is responsible for the hang of this entire gallery. In red, white and black, and with 'a centrepiece like a scream' (Hoyland), this assertive installation isn't necessarily what Frost's many admirers expect from him. Nor, for different reasons, are the two earlier works included here. One, called *Walk on the Quay*, is a relatively early abstract dominated by green, from which Frost's characteristic circles and segments of circles are entirely absent. The other, earlier still, is reputedly the composition that Ben Nicholson loved when he first saw it in Frost's studio. There's no mystery about the enthusiasm: every inch of the Frost betrays an appreciation of Nicholson's pictorial language.

Hoyland was a close friend of Frost, so it's appropriate that one of his own paintings here should be *Elegy for Terry Frost*. 'It's an emotionally dark picture,' observes Hoyland, while its companion, *The Golden Traveller 21.3.2004*, is 'moving on into the warmth, the sun, everything that means so much to me'. Hoyland adds that he took pains to hang his own pictures especially well: 'I'm now 70 and in five years I'll become a Senior Academician.' In other words, he'll never be involved in the organisation of another Summer Exhibition. Perhaps his tongue is in his cheek when he adds that 'once the younger people take over, they'll insist on showing my work in the worst possible light'.

Apart from a composition by Allen Jones ('I like the unexpected colours,' says Hoyland), this gallery is filled with abstracts by Members. There's one of John Wragg's pristine reliefs in white and boiled-sweet colours; two small, lively compositions by Bert Irvin; and a painting by Maurice Cockrill, *Daughter of the Sun*, which exploits the dynamic tension set up between the figure and the ground.

Prof. John Hoyland RA
The Golden Traveller 21.3.2004
Acrylic
235 × 254 cm

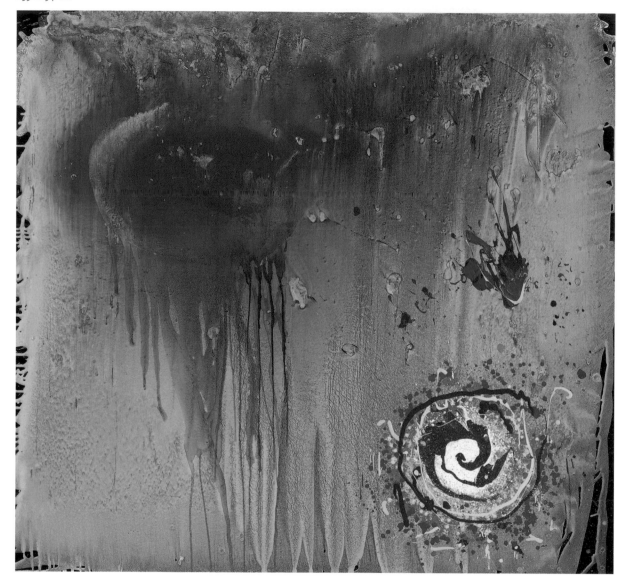

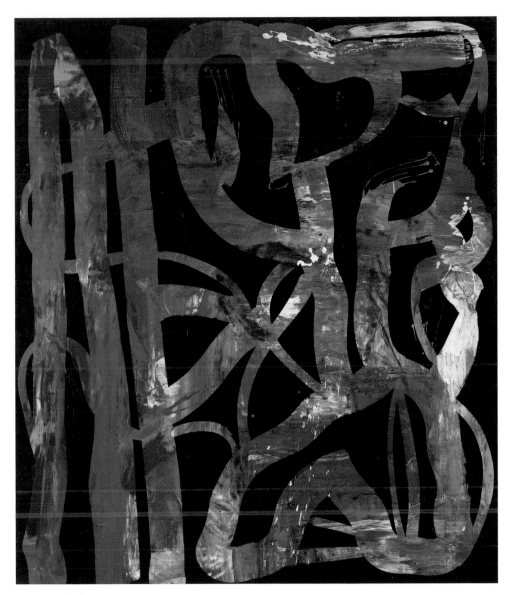

Maurice Cockrill RA
Daughter of the Sun
Oil and acrylic
213 × 182 cm

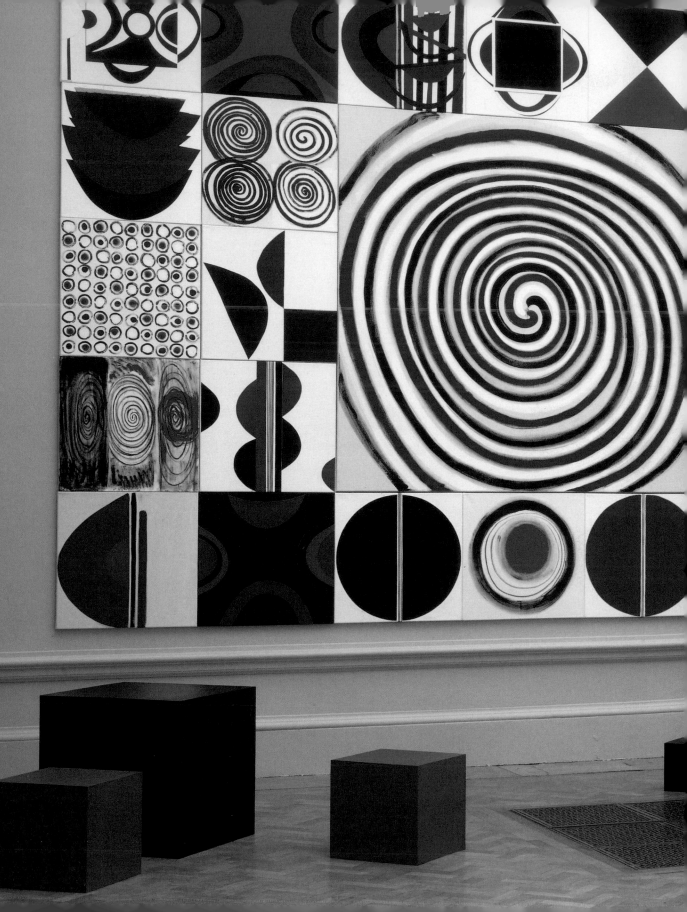

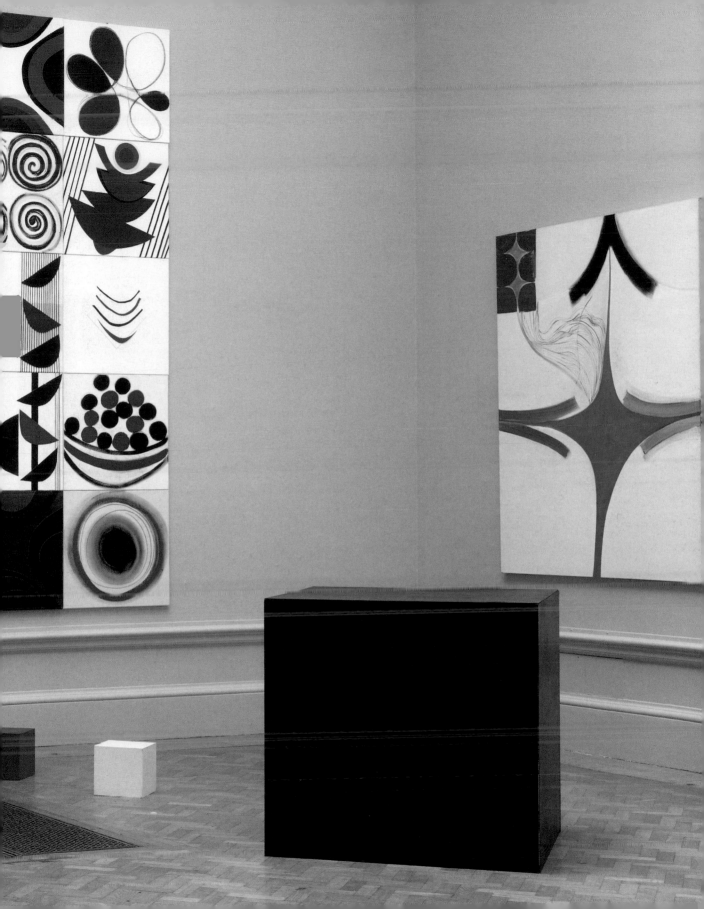

John Wragg RA
Harmonic Shimmer II
Mixed media
153 × 122 cm

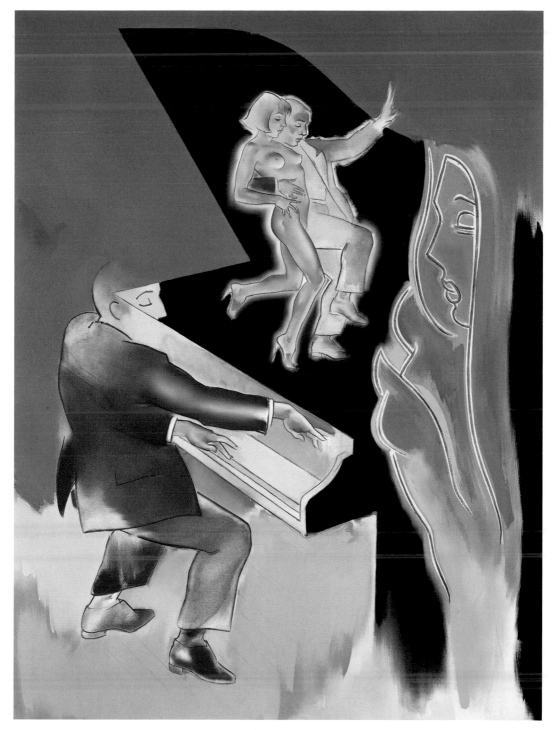

Allen Jones RA
Play for Today
Oil
242 × 181 cm

Most of this large gallery is devoted to prints in every imaginable technique and on every imaginable scale. 'We've tried to show examples of every kind of print being made today,' says Brendan Neiland, who had the difficult task of creating at least an illusion of unity from so much variety (there's even a wall of animals, many of them dismayingly furry). 'We've got digitally produced images, as well as more traditional woodcuts (some amazingly large), etchings and lithographs. But many of those using the oldest techniques are at the same time experimenting and testing the limits of the medium.'

One of the largest woodcuts is Peter Belyi's *Zeppelin Attack* – so assertive in black and white that you wonder how anything else within range can live with it. Sandra Blow's scintillating screenprint *Brilliant Corner III* also captures the attention, as do Gillian Ayres's hand-coloured etchings that have somehow been given the substance, texture and thrilling colour of her oil paintings. Less insistent but just as appealing are Norman Ackroyd's etching *Ludlow* and Jennifer Dickson's etching and watercolour of the Alhambra, Granada.

Many of the artists here have work in other galleries, too. Christopher Le Brun's fetching monotypes of Venice can more than hold their own with his symbolist paintings next door. Ivor Abrahams's owls, one of them described as inebriate, are clearly related to the huge, light-hearted sculpture of the bird that presides over the Lecture Room. A different sort of joke is provided by Glen Baxter's improbable confrontation of the new art and the Old West, while a lithograph, created jointly by Anthony Green and his artist wife Mary Cozens Walker, commemorates a marriage that, after forty years, still provides each of them with limitless subject matter.

Among the many familiar names here are Jim Dine, Joe Tilson and Richard Hamilton. Hamilton's small lithographs reprise two of his best-known early paintings, *$he* and *Hers Is a Lush Situation*. Peter Blake's silkscreen *Love Me Tender* is a literally glittering tribute to Elvis Presley, in which the silhouette of the rock star is filled with a substance that sparkles like granulated sugar. Eduardo Paolozzi, 80 this year, joins this Pop Art company in the shape of two small lithographs, and a screenprint from one of his most handsome series, *Calcium Night Light*.

Alan Cox
Pegs
Lithograph
63 × 88 cm

John Duffin
*World Service (BBC Bush House,
Aldwych, London WC2)*
Etching
38 × 25 cm

Simon Lawson
Wandsworth
Sugarlift etching
16 × 10 cm

Boyd & Evans
Taos
Photographic
inkjet print
76 × 90 cm

John Davies
Tama for a Loved One 2002
Etching and aquatint
25 × 19 cm

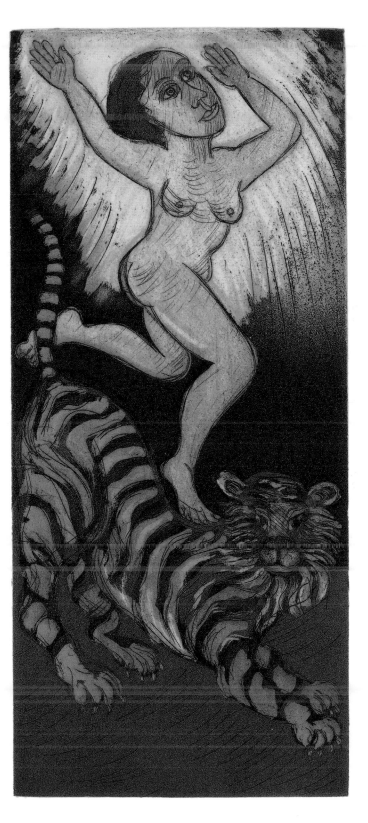

Eileen Cooper RA
Wild Times
Etching
32 × 13 cm

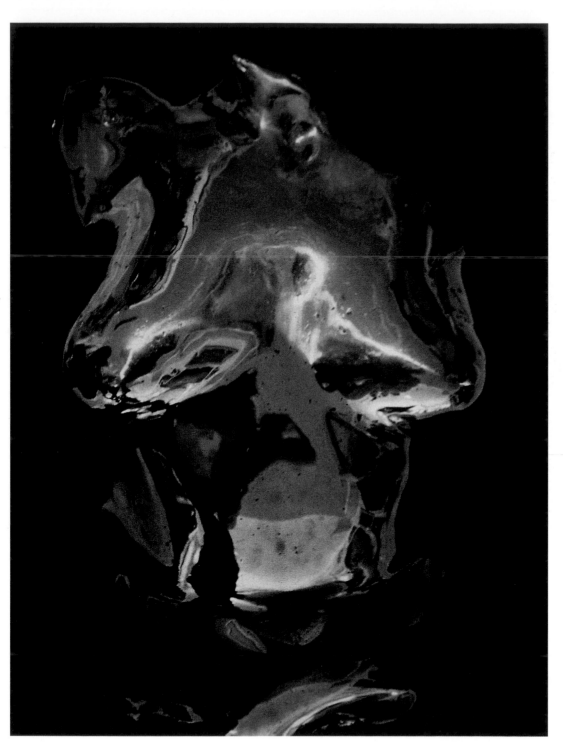

Prof. John Samuel Dishman
Fluidity of the Anatomy
Digital print
65 × 50 cm

Julian Opie
*Woman Taking Off Man's Jacket
in Five Stages*, 2004
Screenprint
47 × 87 cm

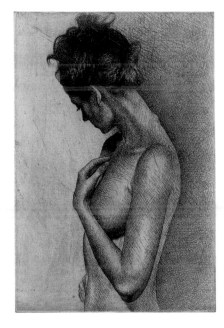

Mark Clark
Nude
Etching
28 × 19 cm

Joe Tilson RA
Conjunction, Red Admiral, Pietra
Screenprint
55 × 75 cm

Peter Freeth RA
Doctor from St Luke's
Aquatint
49 × 60 cm

Brad Faine
Vanity, Vanity, Vanity
Inkjet screenprint
82 × 59 cm

Divyesh Bhanderi
Onyx
Etching
59 × 59 cm

Keith Hogan
Night in Lucca
Drypoint etching
10 × 15 cm

Charles Carey
Jug and Coffee Pot
Aquatint
66 × 89 cm

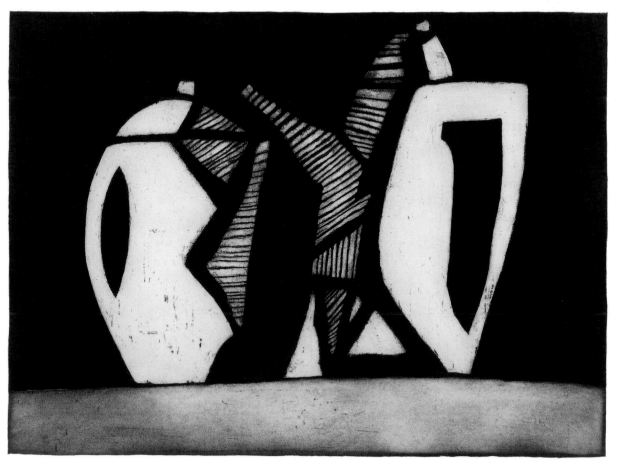

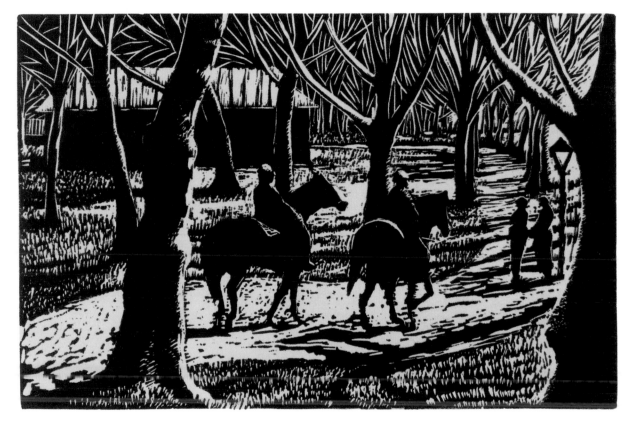

Bill Jacklin RA
Encounter C.P.
Linocut
20 × 29 cm

Prof. Norman Ackroyd RA
Ludlow
Etching
20 × 23 cm

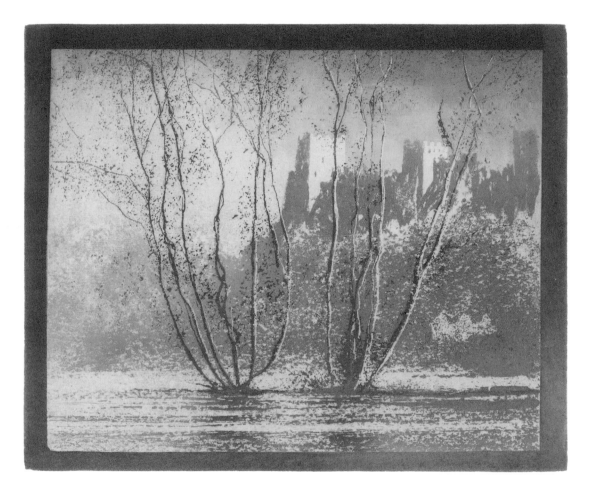

Dr Jennifer Dickson RA
Torre De Los Damas, The Alhambra, Granada
Etching and watercolour
20 × 28 cm

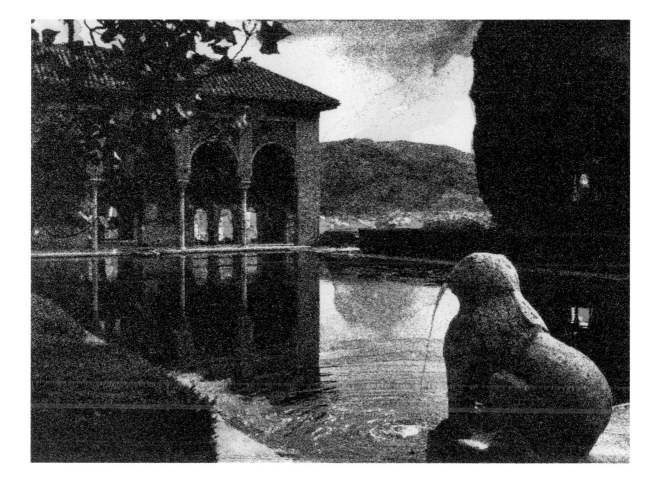

Ivor Abrahams RA
Inebriate Owl
Screenprint and
inkjet
100 × 68 cm

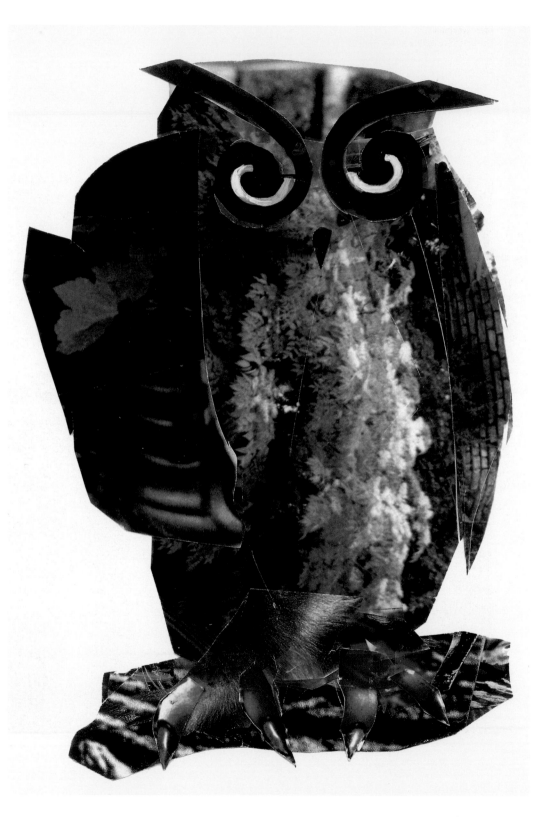

Mary Norman
Valentino: Barred Wyandotte
Linocut
50 × 46 cm

Vincent Jackson
Canoeing the Tweed
Linocut
15 × 20 cm

Catriona Colledge
Boats
Linocut
44 × 24 cm

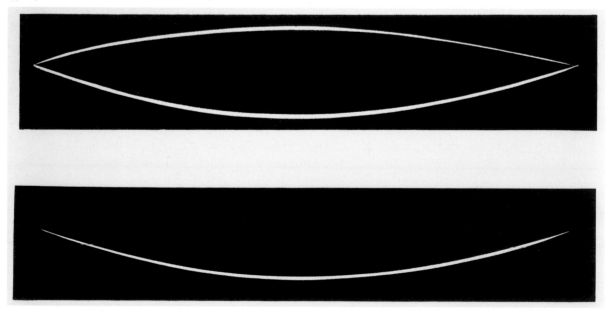

Bill Woodrow RA
North Shore Boat, Lock Maree
Linocut
40 × 30 cm

This space, unlike any other in the exhibition, is by tradition devoted to a host of small paintings with the addition of a few works in other media. So many pictures need to be accommodated that many of them are hung in ways that make them difficult to see well. Artists would rather have their work here than nowhere, however, and visitors seem to enjoy taking everything in. Most of the pictures are figurative. Few are remotely difficult or challenging. But to dismiss everything here out of hand is to deny oneself the pleasure of looking carefully at work that, though quietly spoken and well-mannered, has interesting things to say.

Olwyn Bowey hung the room and therefore had the difficult task of fitting everything together harmoniously. She compares her task 'to solving a giant jigsaw puzzle, during which some pieces unfortunately need to be discarded because they don't seem to belong anywhere. I'm really very sad that I had to reject some beautiful pictures simply because they struck a jarring note in the company they appeared in. Many of the frames are more of a hindrance than a help, too.'

It's probably invidious to select for special comment any of these highly assorted pictures. But *Untitled*, a self-portrait by Nadia Hebson (a familiar contributor to this room), stands out. It's an intriguing hybrid of contemporary realism and fifteenth-century Flemish painting with all its slow, technical precision (it's even painted on copper). Michael Fairclough's heavily impastoed, expressionist seascape also deserves mention, as does Bernard Dunstan's atmospheric *The Green Lamp* (one of three paintings in this room by an artist whose work is always noticed at Summer Exhibitions). Sarah Bookless's extrovert cityscapes seem to use every colour in the box.

Robert Dukes
Two Lemons
Oil
27 × 23 cm

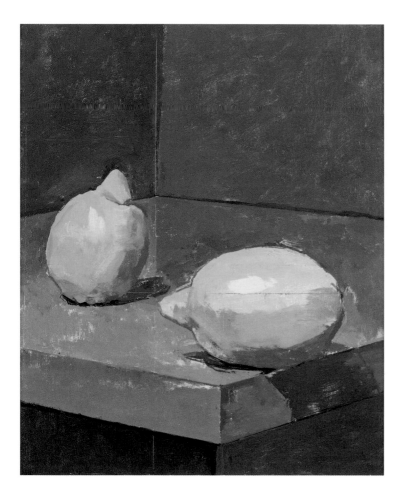

Toby Wiggins
Fifty Summers Past
Oil
30 × 40 cm

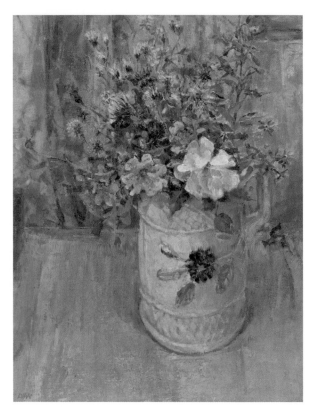

Diana Armfield RA
Hedgerow Flowers in August, Llwynhir
Oil
41 × 30 cm

Jane Dowling
Life Study at the Ruskin
Egg tempera
36 × 34 cm

Edmund Chamberlain
Still-life with Dragon Tree Before a Window
Oil
107 × 73 cm

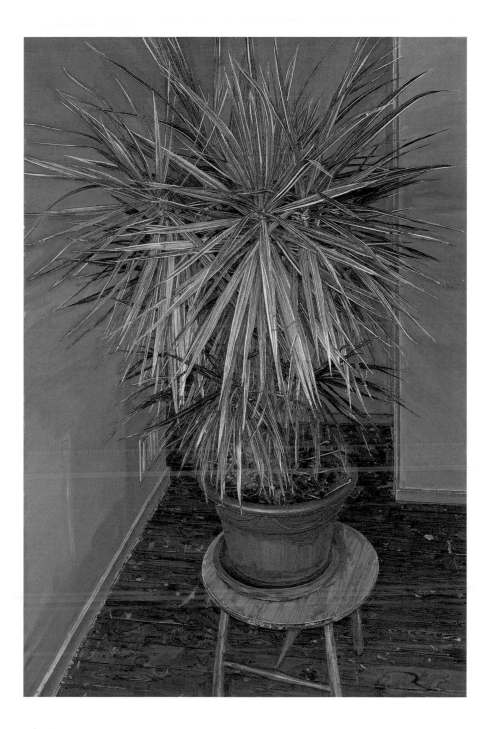

Annie Brain
October Night
Oil
29 × 29 cm

Malcolm Ashman
Into the West
Oil
23 × 28 cm

Danny Markey
Queuing Traffic, Sunset
Oil
23 × 29 cm

Michael Fairclough
Aranmore and the Rock of the Ballan Wrasse
Oil
21 × 27 cm

John Wiltshire
Lungwort (at Sissinghurst)
Oil
24 × 36 cm

Flavia Irwin RA
Metal Shadow V
Pencil
30 × 40 cm

Tom Fairs
Broadwalk, Konwood
Oil
53 × 73 cm

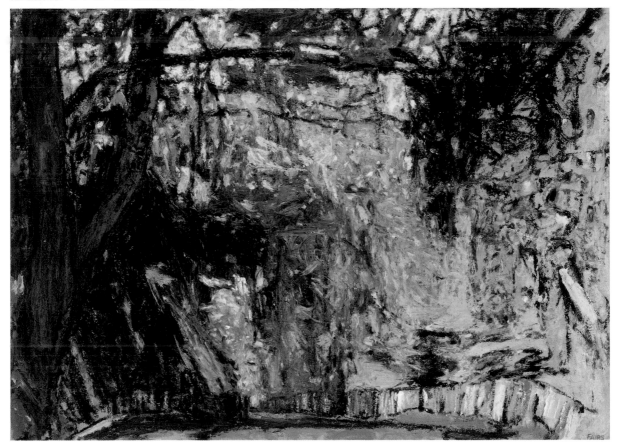

Eileen Hogan
Home House,
Portman Square
Oil and acrylic
63 × 50 cm

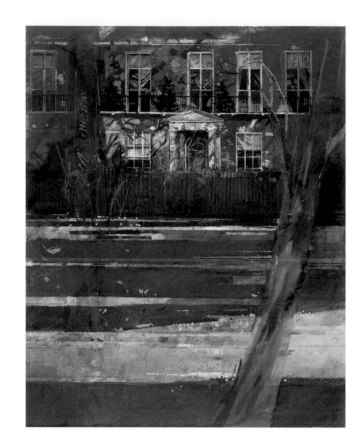

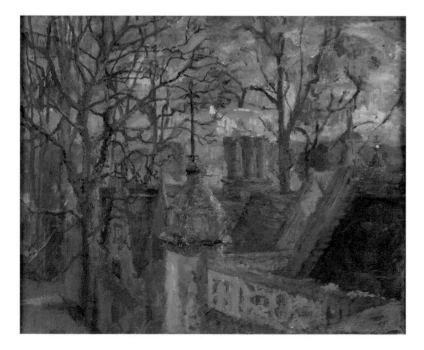

Edmund Fairfax-Lucy
Early Morning, Winter
Oil
50 × 61 cm

James Lloyd
Helicopter
Oil
19 × 19 cm

Charles Hardaker
Opening Door
Oil
38 × 38 cm

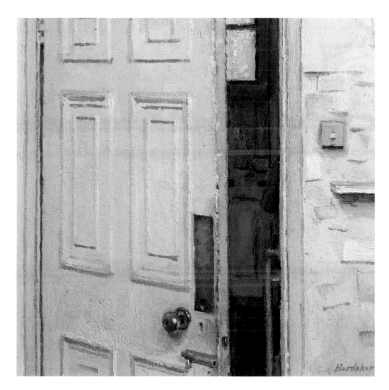

James Butler RA
Working Drawing I
Charcoal, pastel and watercolour
40 × 28 cm

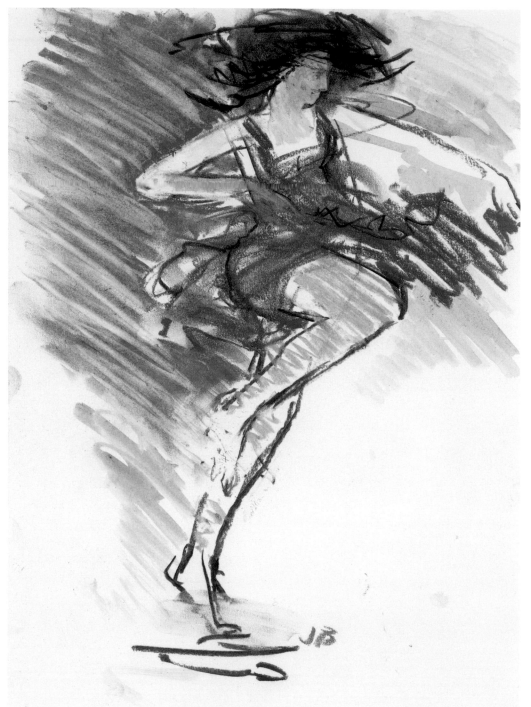

Craigie Aitchison CBE RA
Nude I
Pencil
13 × 18 cm

Gallery III

This large and imposing gallery may be one of the grandest and best-lit exhibition spaces anywhere in Europe, yet it's also one of the most difficult to hang with paintings and sculptures in such a range of styles and sizes. How can you give visual unity to so many works clamouring for attention?

Part of a solution was suggested by David Hockney, on the Hanging Committee this year, who made the point that if the walls weren't so blindingly white a more harmonious effect could be achieved. 'White makes you see the edges of everything,' he says, 'Bring the tone down and everything seems softer.' So here, and throughout the exhibition, the walls are an unaccustomed stone colour.

Although Hockney has been one of the hangers, his contribution was minor by comparison with that of the other exhibition co-ordinator, Allen Jones. During one of his lightning visits, Hockney, grinning, told everyone who'd listen that 'this means you can't blame me for everything'. However, he does eagerly own up to the group of six large watercolours of Spanish subjects that dominate the end wall, one of which is *Andalucia – Alcazaba, Granada*. He's obviously rather pleased with them. 'They're just watercolours,' Hockney says approvingly, 'yet you can see them right from the other end of the room.' He adds that watercolours are important because 'unlike photography', a subject that's been fascinating him for some time, 'they let the hand show. That's why I use very liquid paint and huge brushes.'

Hockney shares the end wall with one of the newest Honorary RAs, Ellsworth Kelly, whose *Two Curves* is a very recent painting. Beside it, given enviably generous space, is a drawing of Mont Sainte Victoire, a reminder that Kelly's uncompromisingly minimal abstracts have their roots in the close observation of nature.

All the artists in Gallery III are Members, and all are consequently well-known to regular visitors. Some perfectly judged arrangements of almost geometric shapes in a few saturated colours by Sandra Blow hang close to a group of ebullient canvases by Gillian Ayres. Adrian Berg's paintings, inspired by visits to the greenhouses at Kew Gardens, are in the same area, as are Elizabeth Blackadder's watercolours of flowers, one of them *Clivia*. Not far away are Sonia Lawson's *Shakespeare's School Desk* and Jeffery Camp's *Cuckmere*. This last, a landscape with self-portrait, marvellously evokes a summer heat haze on the coast with the aid of a dry, rough and high-toned surface.

On an adjoining wall, Frederick Gore's *Rush Hour, 3rd Avenue* captures the look of car headlights and their reflections in the glass façades of New York skyscrapers at dusk.

Elsewhere in Gallery III hangs a triptych by John Bellany, heavy with personal symbolism and blazing with colour, more complex than his smaller still-lifes and figure compositions. One of them is *The Chinese Boy*, who stands on the Great Wall wearing traditional dress. Brendan Neiland's immaculate studies of reflections in the glass curtain-walling of high-rise buildings are nearby; and above them is Anthony Eyton's painting of Bankside Power Station before it was transformed into Tate Modern.

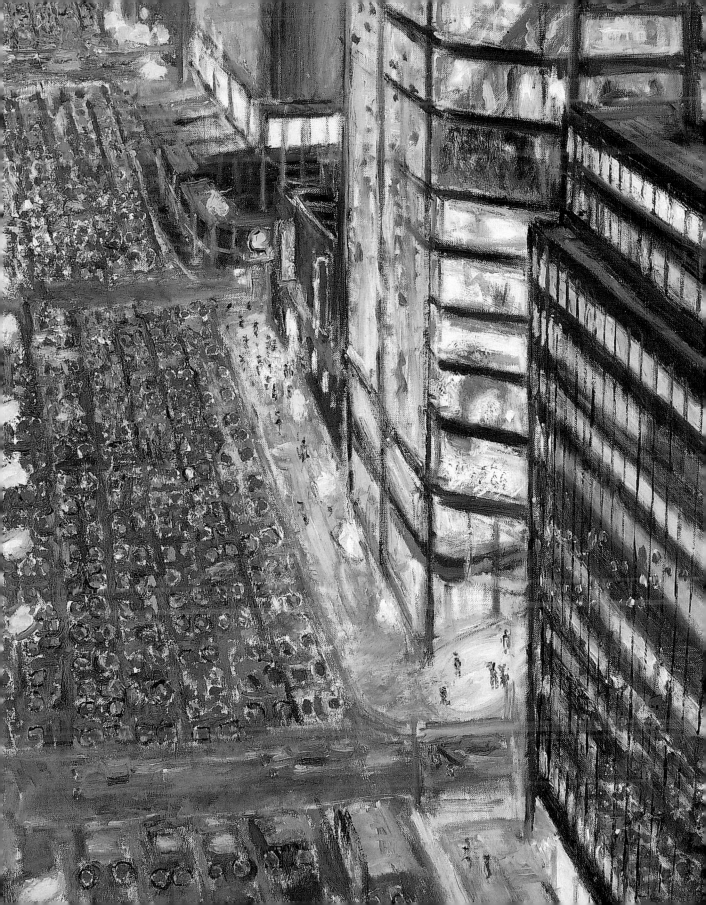

Sandra Blow RA
Demi Semi Quaver
Mixed media
240 × 240 cm

Frederick Gore CBE RA
Rush Hour, 3rd Avenue
Oil
183 × 137 cm

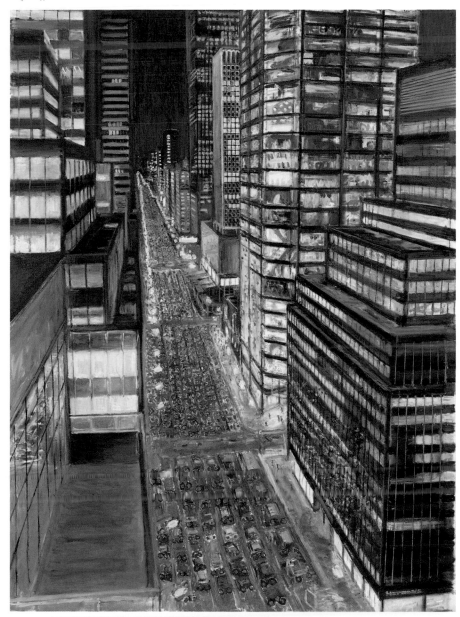

Dr Barbara Rae CBE RA
Inishkea Icon
Mixed media
198 × 183 cm

Dame Elizabeth Blackadder DBE RA
Clivia
Watercolour
70 × 80 cm

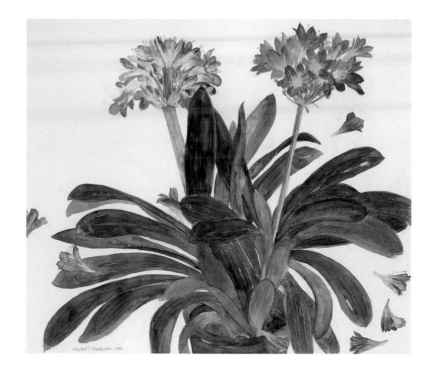

Adrian Berg RA
Flora of Madagascar, Kew Gardens, 1 April 2003 (1)
Oil
61 × 81 cm

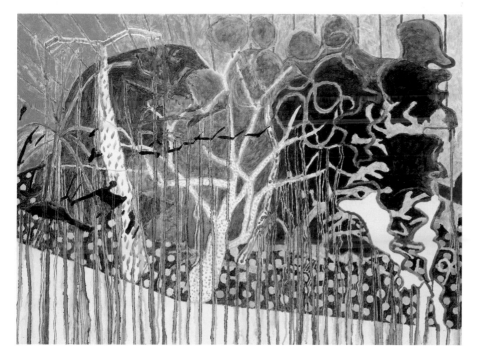

Jeffery Camp RA
Cuckmere
Oil
153 × 214 cm

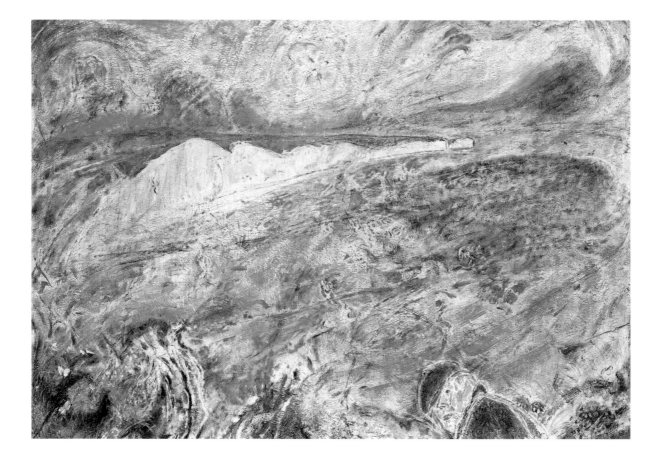

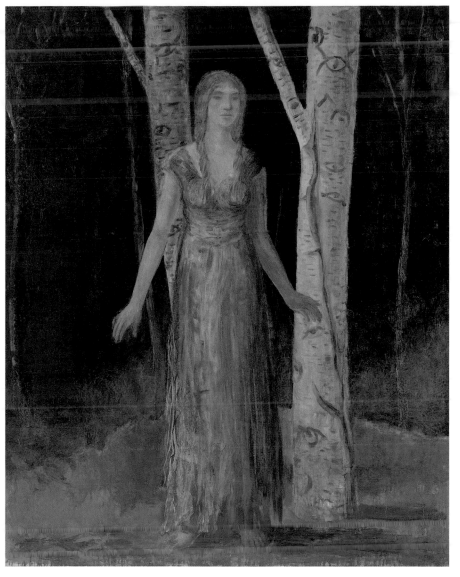

Prof. Christopher Le Brun RA
Mélisande
Oil
152 × 121 cm

Sonia Lawson RA
Shakespeare's School Desk
Oil
165 × 203 cm

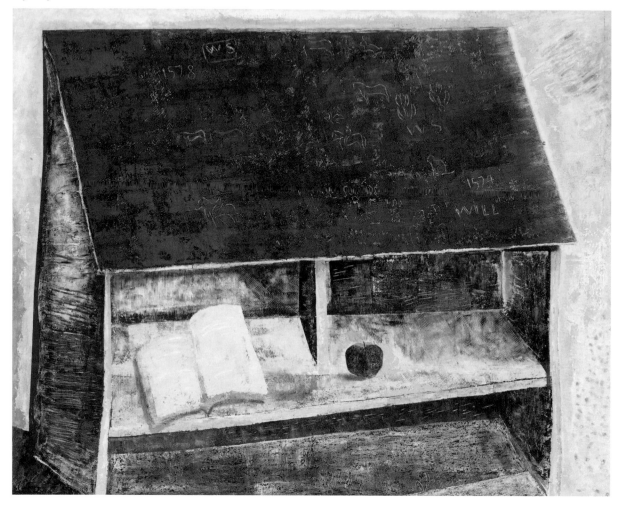

Dr John Bellany CBE RA
The Chinese Boy
Oil
151 x 120 cm

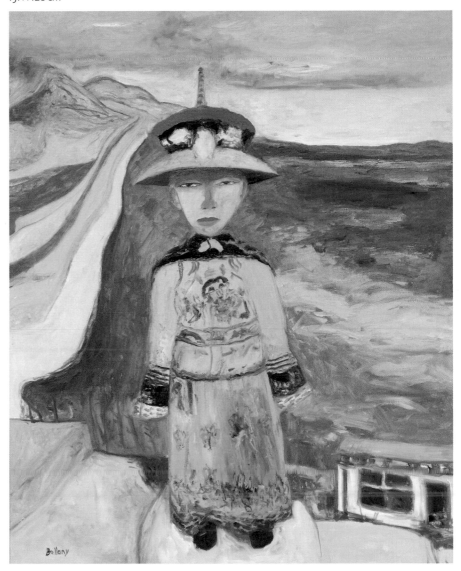

David Hockney RA
Andalucia. Fountains, Cordova
Watercolour
75 × 210 cm

Anthony Whishaw RA
Maelstrom, 2004
Mixed media
182 × 121 cm

Albert Irvin RA
Drydon
Acrylic
183 × 153 cm

Ellsworth Kelly Hon RA
Two Curves 2004
Oil
208 × 195 cm

Gillian Ayres OBE RA
Miranda's Land, 2003
Oil
183 × 121 cm

Gallery IV

This gallery contains paintings and sculptures by Members and Honorary RAs. Among the latter category is Richard Serra, who dominates the gallery in the form of two works on paper: large expanses of dense, roughly textured black on a white ground. Other Honorary RAs here are Antoni Tàpies, Mimmo Paladino, Georg Baselitz and Anselm Kiefer. The six horses' heads, painted upside down, are by Baselitz, while Kiefer's engagement between terracotta model tanks on war-torn and fissured earth isn't so much military as philosophical and artistic. It shows the 'universal battle between Realists and Nominalists', still apparently unwon.

There are two invited artists, too. Frank Auerbach's drawing, *Head of David Landau*, is grouped with Leon Kossoff's *Head of John Lessore*, and the two artists' sustained, intense interest in drawing over many decades gives these works peculiar force in an exhibition whose major theme is drawing. Part of the same arrangement are two paintings and a self-portrait in charcoal by R. B. Kitaj. One of the paintings is entitled *School of London Diasporists*, to which, if the school had ever really existed, both Auerbach and Kossoff would surely have belonged.

Sculpture, for once, is given special attention in this gallery. There's *...to be beside the sea* by the President, Phillip King, a poised arrangement of disparate elements including stones, feathers, cockleshells, all of which is surmounted by a black, petrified banana, complete with label. Anthony Caro, one of the most recently elected Academicians (as well as a former student at the Academy Schools), shows the curiously titled *Emma Scribble*, one of his dynamically stacked arrangements of metal pipes, sheets and beams.

Two almost identical compositions by Allen Jones reveal something of the artist's methods. In both, a magician is coupled with a voluptuous female. One is the drawing for the other. Usually Jones paints over the drawing on the same canvas, but aware of this year's emphasis on drawing, he kept the preparatory work, squaring it up for the coloured version.

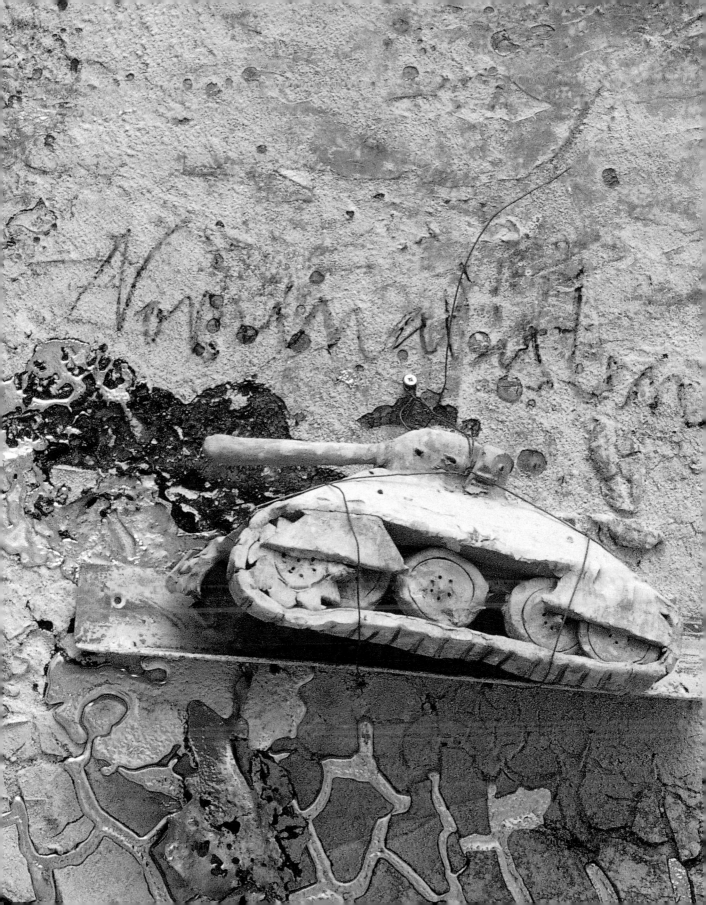

Frank Auerbach
Head of David Landau, 2003
Pencil and crayon
76 × 57 cm

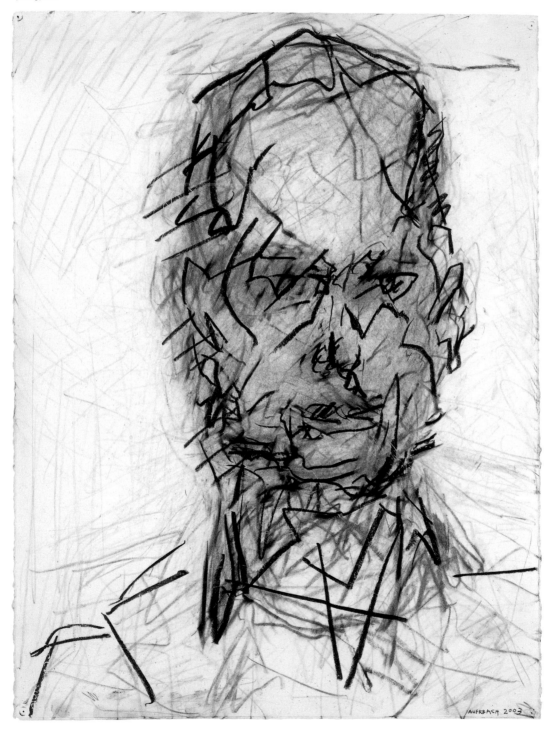

Leon Kossoff
Head of John Lessore, 2002
Chalk
76 × 56 cm

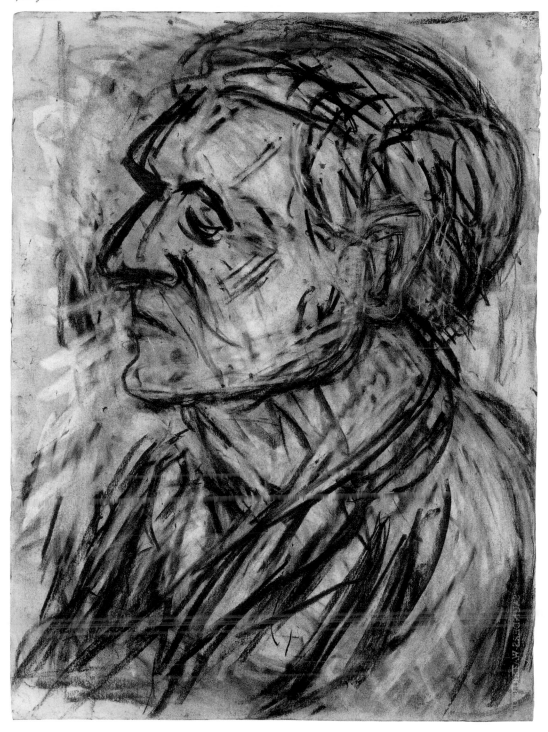

Georg Baselitz Hon RA

1 *Karl May war der Erfinder,*
 27.IV.2003
 Oil
 129 × 97 cm

2 *Ein Pferd in den 60.igern,*
 29.IV.2003
 Oil
 130 × 97 cm

3 *Ein Pferd allein, 28.IV.2003*
 Oil
 130 × 97 cm

4 *Pferde ade, 1.V. 2003*
 Oil and metallic pigment
 130 × 97 cm

5 *Winterzeit, 3.V. 2003*
 Oil
 130 × 97 cm

6 *Schneeroman, 2.V. 2003*
 Oil
 130 × 97 cm

1

4

2

5

3

6

Anselm Kiefer Hon RA
Der Universalien Streit, 2003
Mixed media
190 × 330 cm

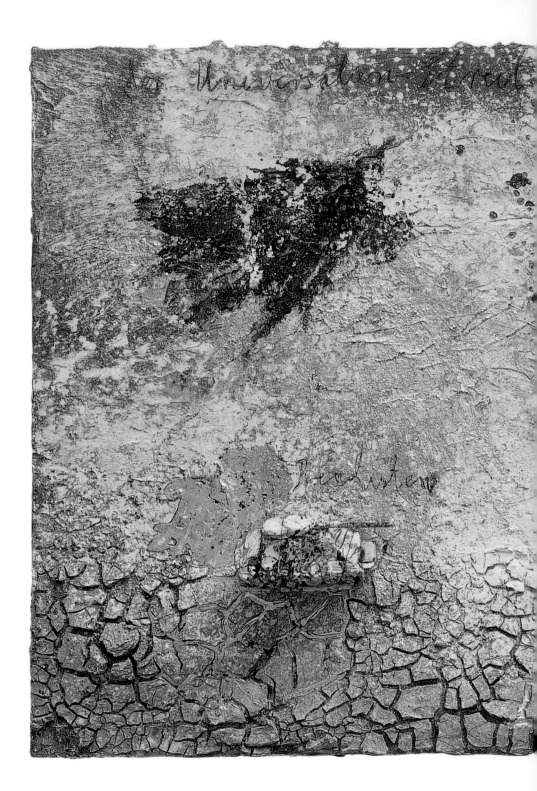

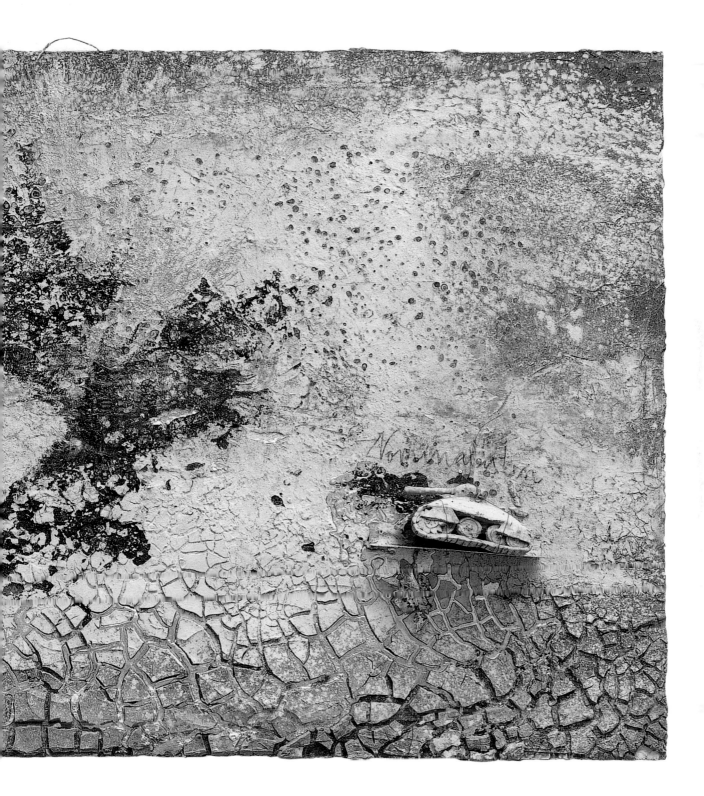

Prof. Phillip King CBE PRA
... to be beside the sea
Mixed media
H 185 cm

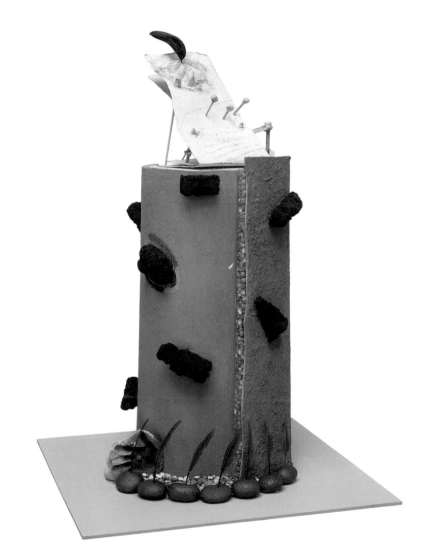

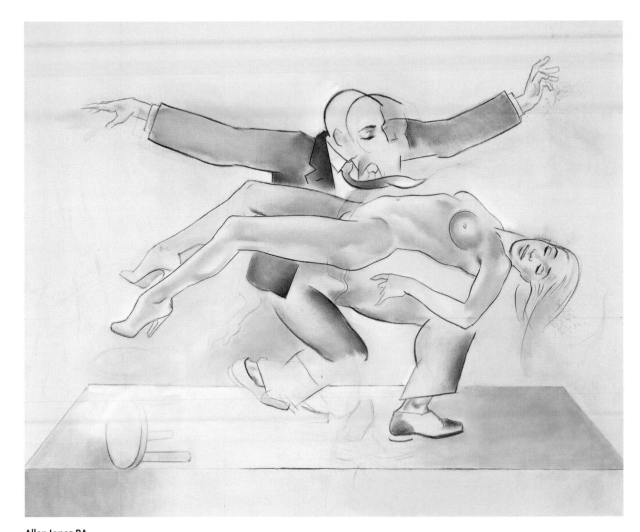

Allen Jones RA
Levitation Meditation
Oil
153 × 183 cm

Richard Serra
Hon RA
Deadweight X
(Memnon) 1991
Paintstick
359 × 192 cm

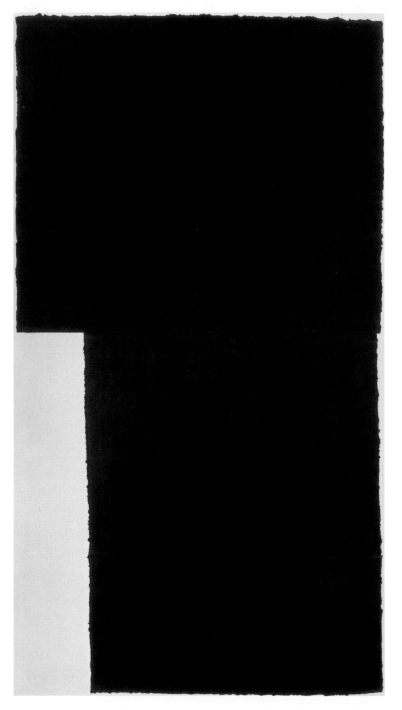

Sir Anthony Caro
OM CBE RA
Emma Scribble
Steel
H 198 cm

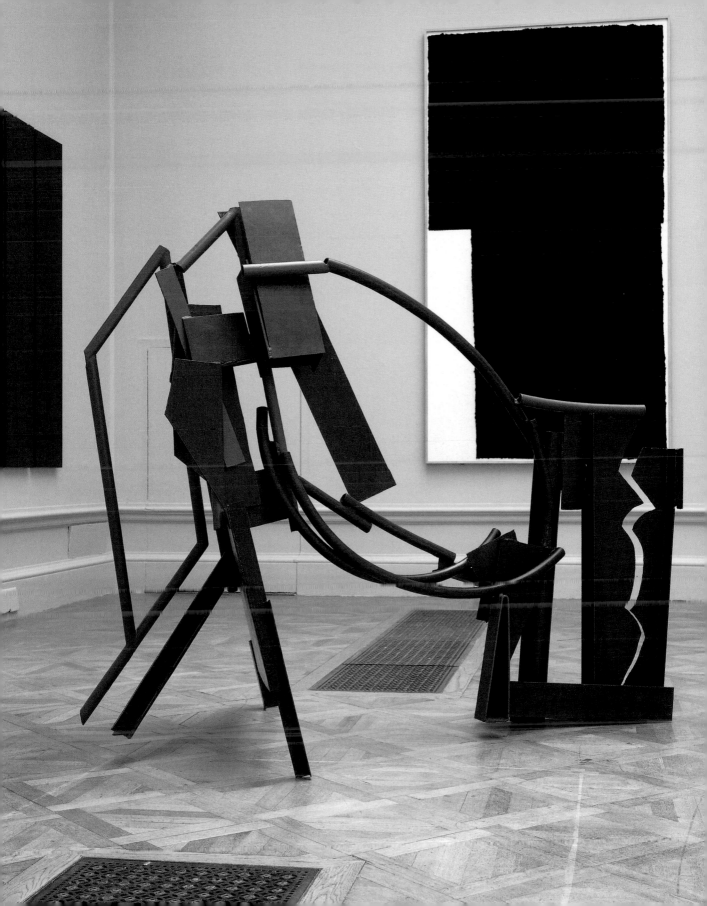

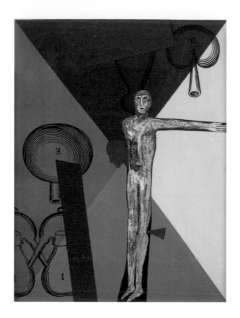

Mimmo Paladino Hon RA
Untitled
Mixed media
41 × 31 cm

Antoni Tàpies Hon RA
Petit diptyque noir et rouge
(Small Black and Red Diptych), 1987
Painting and collage
68 × 108 cm

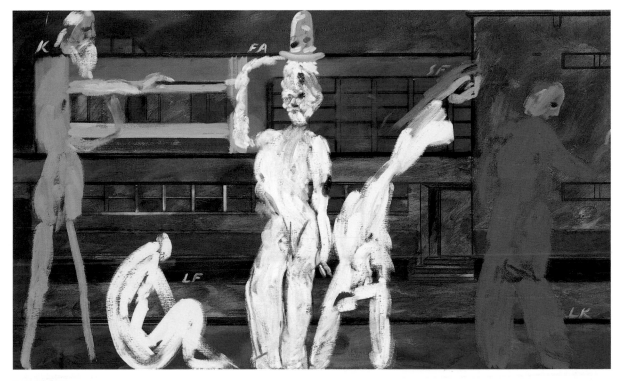

R B Kitaj RA
School of London Diasporists 1988 – 2004
Oil
92 × 152 cm

Gallery V

Nearly all the works in Gallery V, mostly by Members, are devoted to drawing, the theme of this year's Summer Exhibition. Compared with those next door in Gallery VI, the drawings in this gallery are more colourful, less black and white.

Brendan Neiland, Keeper (and therefore Principal) of the Royal Academy Schools, was responsible for the hang. He stresses the 'fluidity, spontaneity and naturalness' of most of these drawings. 'There's an organic feel to almost everything here. So much of it looks as if it's grown directly on the paper – like the drawings by David Nash, for example. They're even made with a mixture of leaf mould and charcoal. The brush drawings by Stephen Cox also look like living things. They quiver like jellies.'

At first sight, the 48-piece array of individually framed, highly artistic doodles by Tom Phillips looks like a breach of the regulations: Members may include a maximum of only six works in the exhibition. The doodles do belong together, though. Most were made during *longeurs* in various Academy meetings, and you may be forgiven for enjoying the opportunity to read someone else's business more than examining the drawings.

Also worth mentioning here are the studies for two Stations of the Cross by Damien Hirst, who's replaced Christ and the other customary figures with shorn, hornless sheep. Three geometric compositions by Michael Kidner, glowing with colour and reminiscent of Islamic patterns, are hung quite high up, but you can't miss them.

Brendan Neiland is exhibiting two overlaid, hand-cut stencils for one of his spray paintings, very much like those in Gallery III. 'Stencils serve the same purpose as drawings for me, and they therefore belong together with all the other drawings in this gallery.'

Finally, there's a Roy Lichtenstein painting together with its preparatory drawing in coloured pencil; both are given plenty of room to breathe. Allen Jones explains what they're doing here: 'They're a belated memorial to an old friend and sometime Honorary RA, who died in 1997.'

John Carter
Spiral Line: Square Format 2004
Mixed media
122 × 122 cm

Ann Christopher RA
Shadow Line – 13
Conté, pastel and graphite
70 × 49 cm

Ian McKeever RA
Filament III, 2001
Gouache
41 × 59 cm

John Maine RA
Enclosure
Pencil
57 × 65 cm

David Nash RA
Ash Dome
Leat mould and charcoal
56 × 75 cm

Michael Sandle
Study for Trafalgar Square
Ink and wash
97 × 74 cm

Prof. Brendan Neiland RA
Bill Board Drawing
Pencil and acrylic
104 × 143 cm

Prof. Bryan Kneale RA
Dorado
Stainless steel and brass
H 26 cm

Kenneth Draper RA
Dark Light / Light Shadow
Mixed media
61 × 35 cm

Tom Phillips CBE RA
Merry Meetings (48 Sections) (detail)
Pen and ink
21 × 29 cm

Stephen Farthing RA
Woman in a Dress #4
Acrylic
51 × 40 cm

Damien Hirst
From the Stations of the Cross No. XIII
Pencil
118 × 83 cm

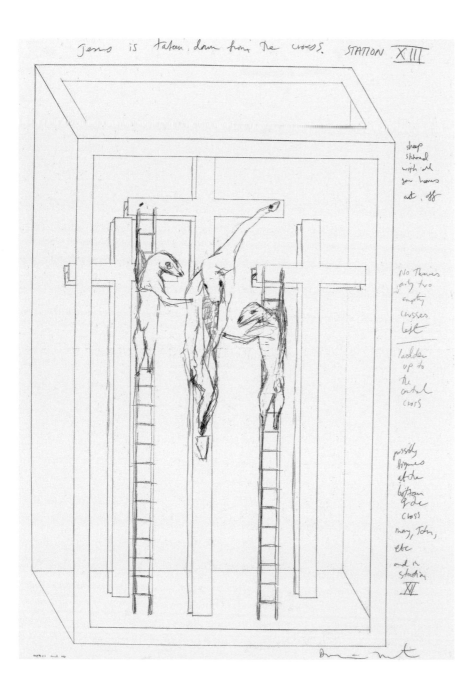

Michael Craig-Martin
Pricks
Tape on drafting film
97 × 71 cm

Prof. David Mach RA
Princess
Postcard collage
144 × 235 cm

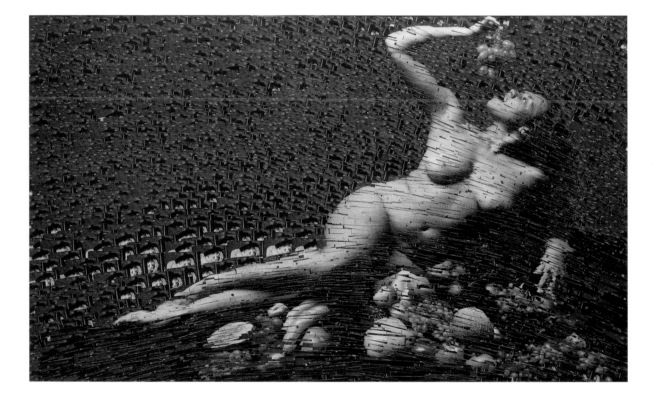

The late Roy Lichtenstein Hon RA
Collage for Reflections on Conversation
Mixed media
121 × 154 cm

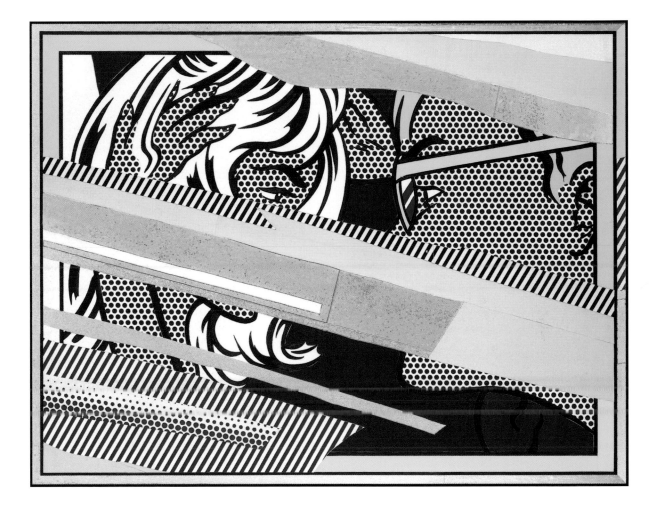

Gallery VI

The main feature of this important gallery, hung by Allen Jones, is the group of drawings by non-artists mentioned in the Introduction. The work of distinguished scientists, surgeons, composers, film directors, sportsmen and others, they're genuinely fascinating, not least because it's unusual to have the opportunity to see such work at all. All the non-artists (if they can be so described) responded enthusiastically to the invitation to exhibit their work, and thus to demonstrate how important drawing is to them as an aid to explanation and description.

Alan Parker has lent a storyboard for his film *Midnight Express*. There are scores by Karlheinz Stockhausen, and pictorial notes about operations by Francis Wells, the heart surgeon. Michael Peckham graphically illustrates advances in cancer theory, and several of Roger Penrose's vivid, almost sci-fi imaginings of how the entire universe might be are on display. Clive Woodward contributes a bold, quickly executed strategic plan for a rugby game. One other invited artist here adds a colourful and topical note to this mostly monochromatic section. Gerald Scarfe shows President Bush accompanied by his poodle Blair at the head of a column of marching coffins draped with American and British flags, presumably retreating from Iraq.

Elsewhere, artists are allowed to take over. Some are Members; others have sent their work in; others still have been invited. One of them is Gavin Turk, who's come up with a mischievous 'drawing' made with wet rings from the bottom of teacups. Tracey Emin, another invited artist, contributes two customarily autobiographical pieces. Two of the send-ins are charcoal drawings by Roy Wright, one a wonderful, large study of an oak tree.

Among the works by Members, Leonard McComb's almost life-size *Portrait of Pippa Wylde*, a star dancer at the Royal Ballet, succeeds in giving, simply in pencil, an impression of pulsating life and light as vivid as any of his paintings. Anthony Green's working drawing for *1987, The Patchwork Quilt and Bob Going Up to Heaven in 1981* gives a clear sense of what drawing means to the artist, or at least how an elaborately detailed and coloured study helps him to conceive and plan the complex format and content of one of his oil paintings.

Sir Alan Parker
Shoot Script for Midnight Express
Mixed media
57 × 44 cm

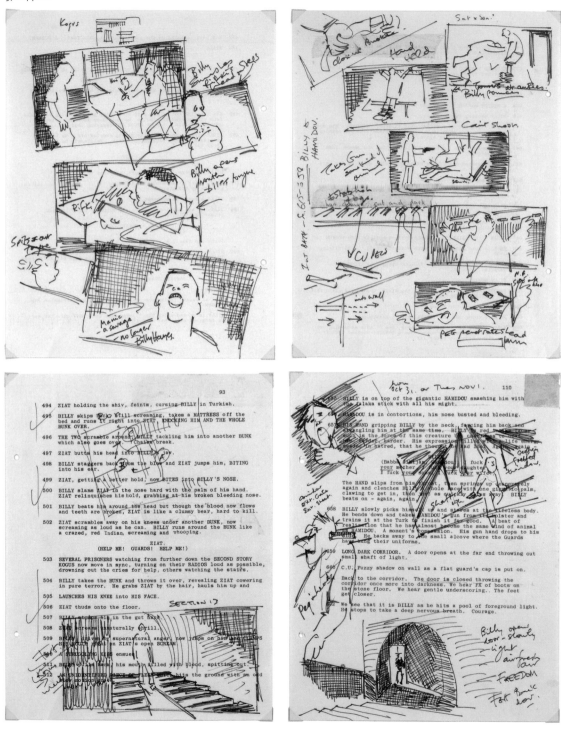

Hussein Chalayan
Untitled (Chair, Girl, Plane, Bird, Flower, Shoe)
Feltpen
65 × 58 cm

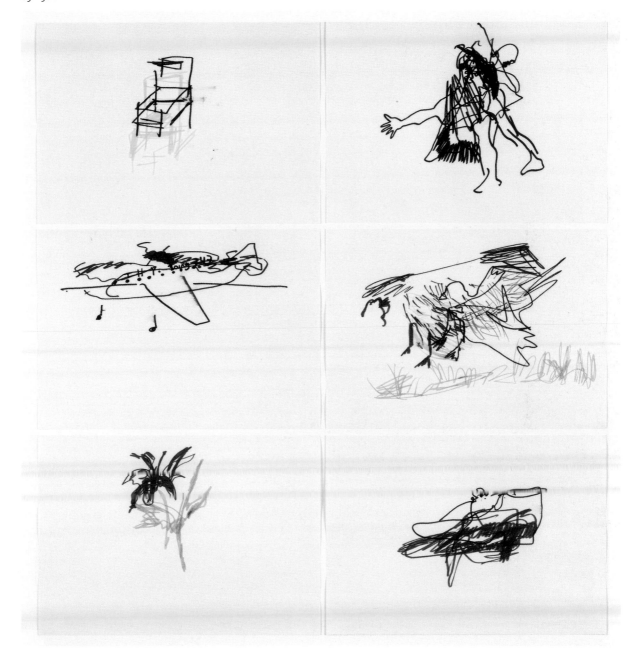

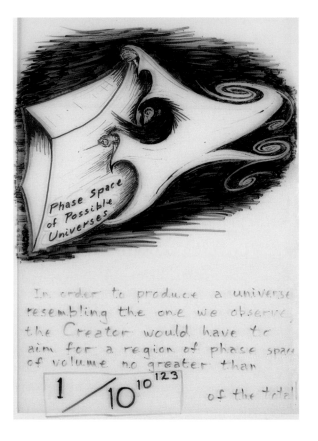

Prof. Sir Roger Penrose
The Creator Having Trouble Locating the Right Universe
Mixed media
29 × 25 cm

The text within the artwork reads:

Phase Space of Possible Universes

In order to produce a universe resembling the one we observe, the Creator would have to aim for a region of phase space of volume no greater than

$$\frac{1}{10^{10^{123}}}$$

of the total.

Dr Francis Wells
Intra-ventricular Path
Ink
14 × 12 cm

WELL ITS
 ALRIGHT
AND. ID LOVE TO
 BE THE
 ONE

LOVE IS WHAT
 YOU WONT

And I'd LOVE to be the one—

Tracey Emin 1997

Tracey Emin
And I'd love to be the one
Monoprint
41 × 29 cm

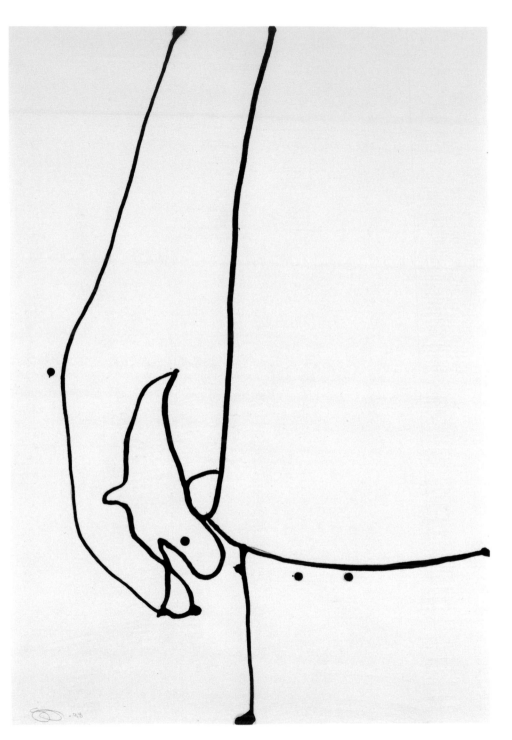

Gary Hume RA
Untitled 0017, 1998
Ink
58 × 40 cm

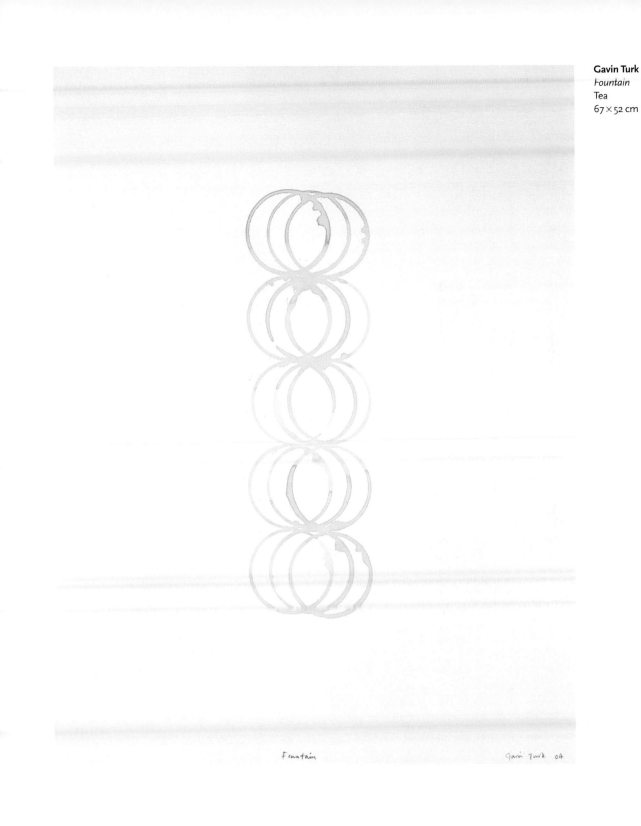

Gavin Turk
Fountain
Tea
67 × 52 cm

Lloyd Durling
Landscape with Deadwood
Ink
21 × 15 cm

Alan Turnbull
The Bird Cherry Tree
Charcoal
66 × 51 cm

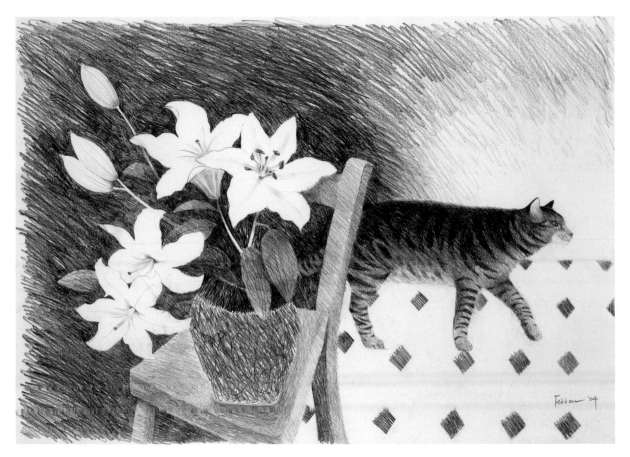

Mary Fedden OBE RA
Cat and Lilies
Pencil
59 × 83 cm

Nicola Tyson
Untitled (sketch book page) no. 6
Graphite
27 × 20 cm

Leonard McComb RA
Portrait of Pippa Wylde –
Star Dancer Royal Ballet
Pencil
178 × 102 cm

Belinda Ellis
Dancers II
Charcoal
41 × 57 cm

Lisa Milroy
Daily Life, 2003
Charcoal
62 × 95 cm

Prof. Sir Peter Blake CBE RA
Death of a Moth
Pencil
58 × 46 cm

Antony Donaldson
Untitled 12 b
Mixed media
58 × 58 cm

Anthony Green RA
*Final Working Drawing for '1987, The Patchwork
Quilt and Bob Going Up to Heaven in 1981'*
Mixed media
120 × 114 cm

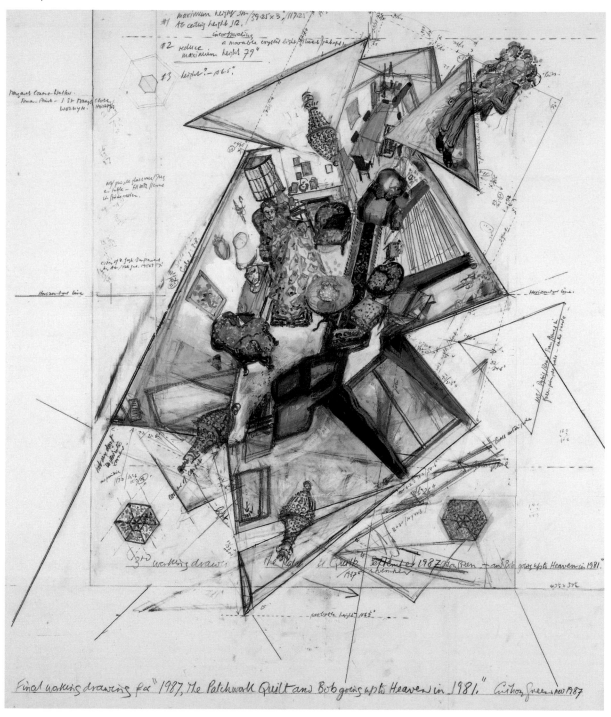

Prof. Christopher Orr RA
Days of Astonishment
Watercolour
84 × 113 cm

Anthony Eyton RA
Manikins, West 8th Street, New York
Pastel and watercolour
36 × 53 cm

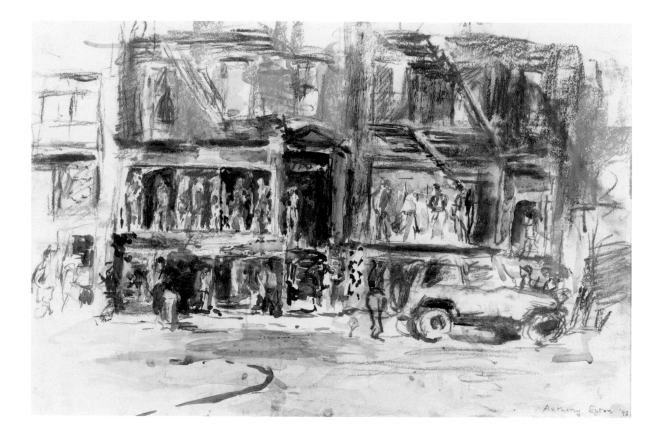

Gus Cummins RA
House Rules
Mixed media
117 × 151 cm

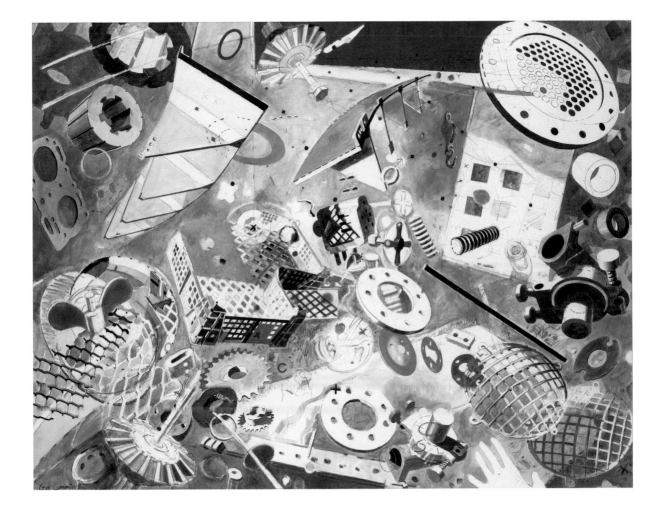

Hylton Stockwell
Private View
Ink
32 × 28 cm

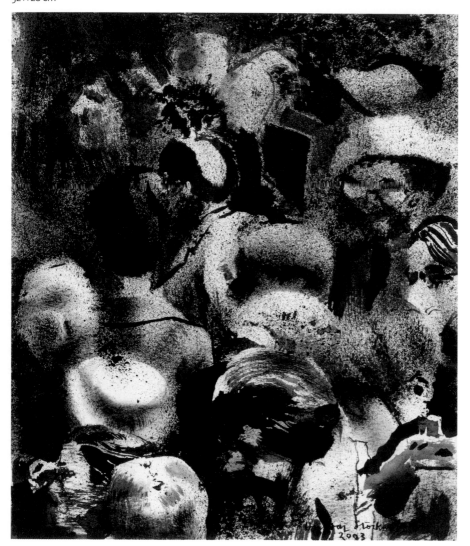

Prof. Sir Eduardo Paolozzi CBE RA
Untitled 1998
Bronze
H 60 cm

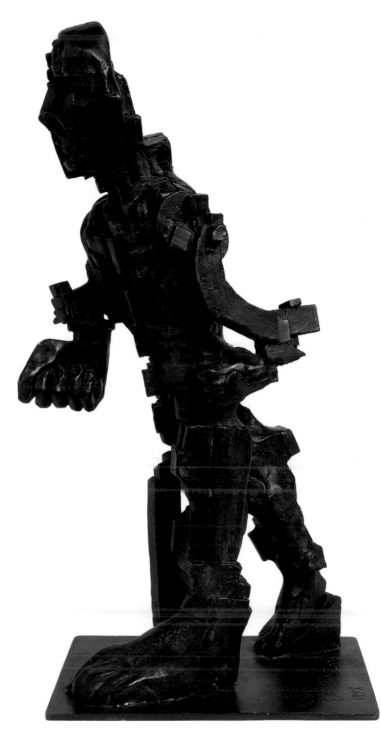

Bernard Dunstan RA
Nude with Bed Jacket
Chalk
22 × 30 cm

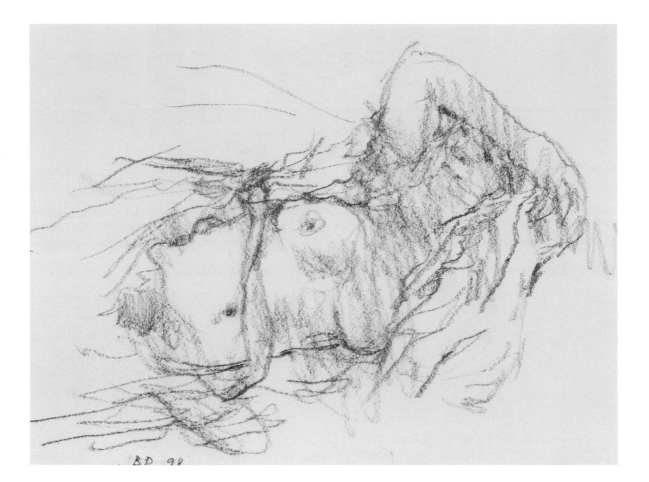

Robert Clatworthy RA
Reclining Figure
Acrylic
27 × 37 cm

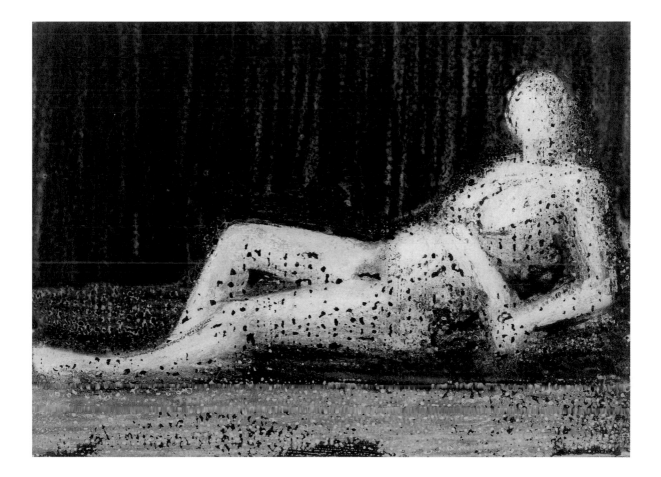

Gallery VII

The three Members who hung the architecture gallery are Piers Gough, Eva Jiricna and Edward Cullinan. Cullinan wants everyone to realise that in this space, too, attention is properly paid to the overarching theme of the whole exhibition. 'The emphasis is on drawing; and here, of course, on architects' drawings. There's a line around the room. Above it are glossy computer images, axonometric views, city plans in two and three dimensions, photographs, that sort of thing, while below the line are mostly drawings, and not just obviously architectural drawings. Leonard Manasseh has a group of things in which he lets his imagination run.'

The pointed cigar shape projected in white light onto one wall is an imaginative memorial to the architect-Member Philip Powell, who died last year. It evokes the Skylon, the futuristic trademark of the 1951 Festival of Britain and probably the most famous building by Powell and his partner Jacko Moya. 'We've made the Skylon hover here,' says Edward Cullinan, 'just as it seemed to hover in the foggy London of 53 years ago.'

The models are for some amazingly varied projects. There's Stuart Cochlin's design for the Baha'i Mother Temple of South America, for instance, and Lord Foster's model for the extraordinarily long viaduct bridge at Millau in France.

Edward Cullinan, always an enthusiast for architects' drawings, is showing one of his own pen-and-ink studies here. Informed by his customary wit and imagination, it describes a project for a park in Castleford that's been given the shape of a tiger. To the side are figures in the strip of the famous Castleford Rugby League team, called, of course, the Tigers (sadly, the project proved too costly and hasn't been realised). Nearby is a series of drawings by Colin St John Wilson, linking some of his so-called *Capriccios* with two of his sketches for the British Library when that most famous of his buildings was at its earliest, most conceptual stage. Other drawings that stand out because of their scale and spontaneity are Frank Gehry's fantastic and Expressionist sketches of Disney Hall, shown here with photographs of the building's interior and exterior.

Finally, as though in gracious acknowledgement of one of this year's two exhibition co-ordinators, there's Piers Gough's elevation drawing of a studio for Allen Jones.

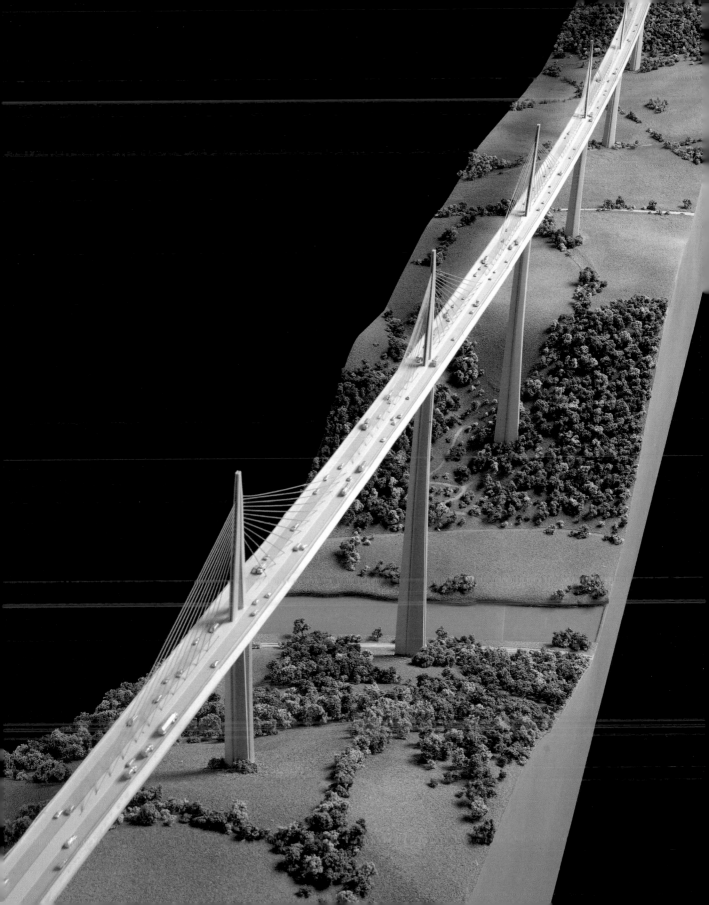

Prof. Sir Colin St John Wilson RA
Capriccio no. 39: Hilltown (1962)
Felt pen
43 × 56 cm

Ian Ritchie CBE RA
Eagle Rock House
Etching
14 × 19 cm

Leonard Manasseh OBE RA
In the Corner of a Wood
Ink
12 × 16 cm

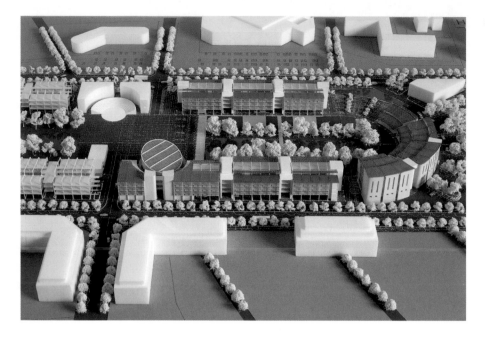

Sir Michael Hopkins CBE RA
(Hopkins Architects)
Pisa, Cisanello – New Council
Offices, Law Courts and Library
Model
H 11 cm

Eva Jiricna CBE RA
(Eva Jiricna Architects)
Boodle and Dunthorne Jewellers,
Liverpool (detail)
Digital image
69 × 94 cm

Prof. Peter Cook RA
(Cook-Robotham-Perez-Arroyo)
Leipaja Concert Hall, Foyer Areas
(detail)
Digital print
49 × 70 cm

Michael Manser CBE RA (The Manser Practice)
Working Studio Model – Extension to Existing
Building at Imperial College, London
Model
H 45 cm

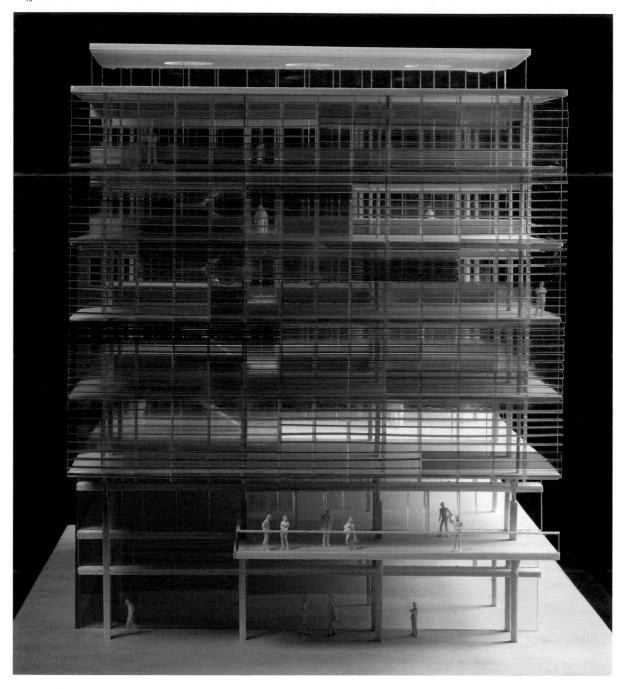

**Lord Rogers of Riverside RA
(Richard Rogers Partnership)**
*122 Leadenhall Street,
City of London, UK*
Digital print
150 × 80 cm

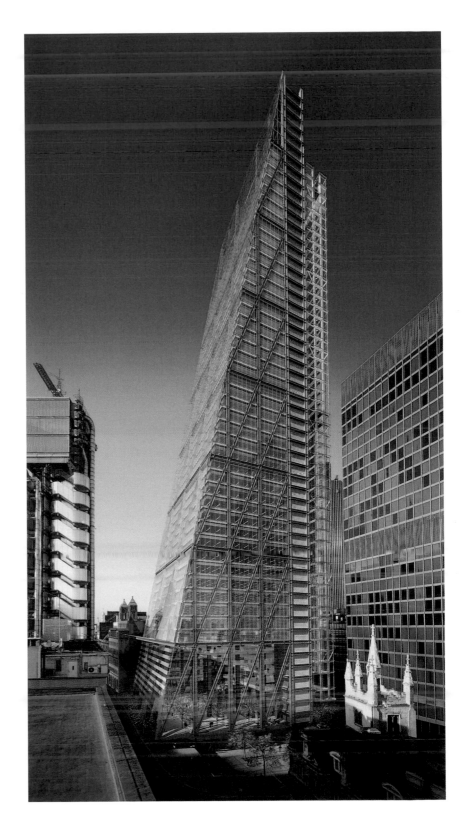

Sir Richard MacCormac CBE RA (MacCormac Jamieson Prichard)
West Cambridge Residencies (Artist: Peter Hull)
Ink
22 × 99 cm

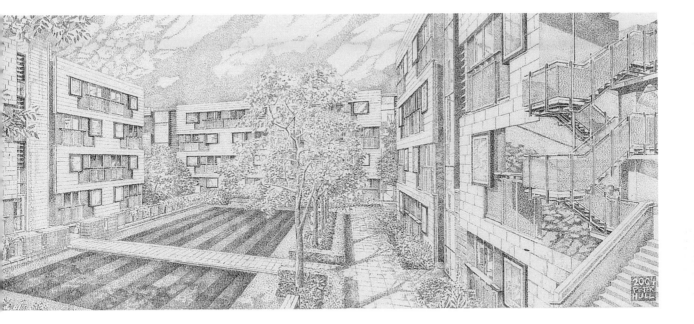

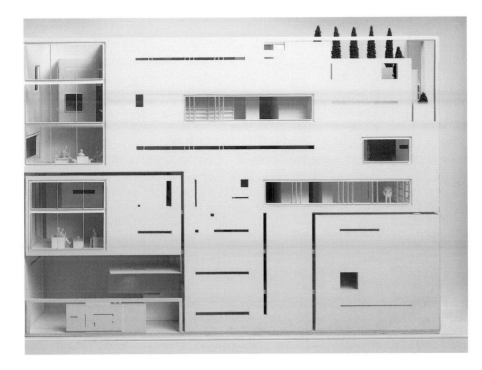

**Prof. Gordon Benson OBE RA
(Benson + Forsyth)**
*Battersea Power Station
Residential (detail)*
Model
H 42 cm

**Prof. Will Alsop OBE RA
(Alsop Architects)**
Bradford Bowl
Model
H 15 cm

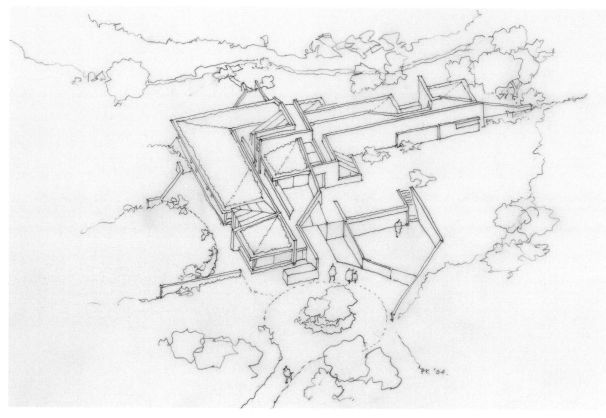

Paul Koralek CBE RA
Collen House, Glencree
Ink
20 × 28 cm

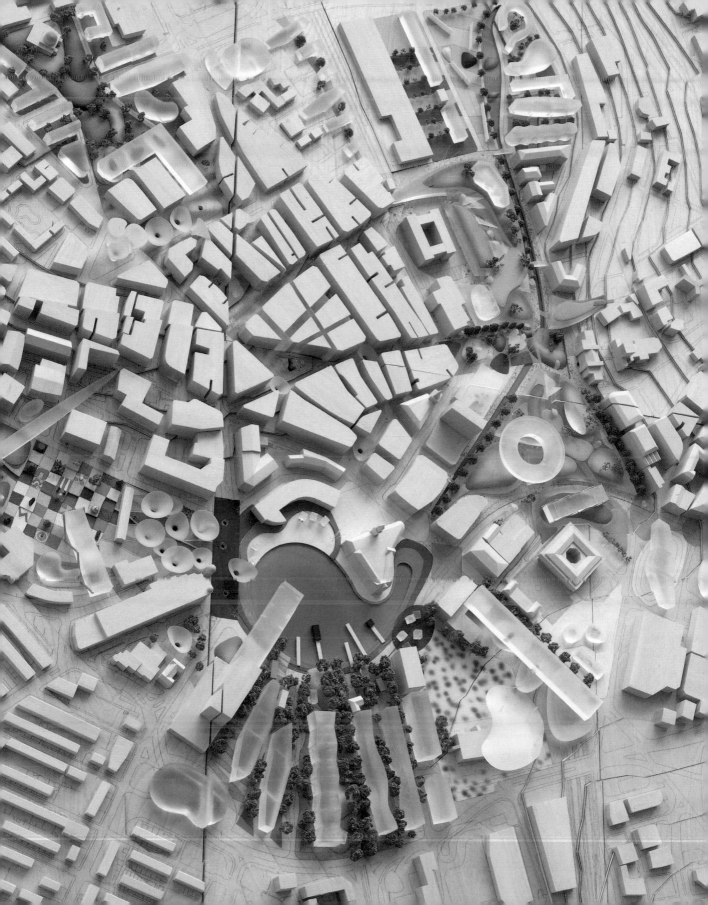

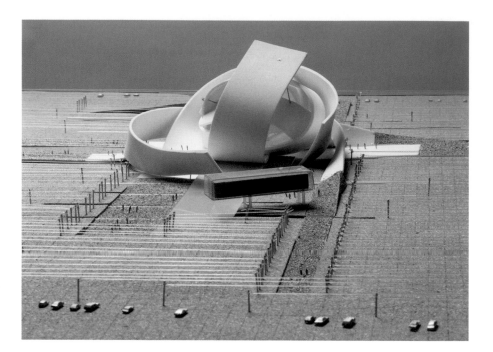

Stuart Cochlin
(Cochlin Hall-Patch Architects)
International Shortlist, Design for
Baha'i Mother Temple of South
America, Chile
Model
H 23 cm

Sir Nicholas Grimshaw CBE RA
(Nicholas Grimshaw & Partners)
Initial Study Models for the Eden
Education Resource Centre Roof Structure
Model
H 17 cm

The late Sir Philip Powell CH OBE RA
Skylon
Photograph
60 x 60 cm

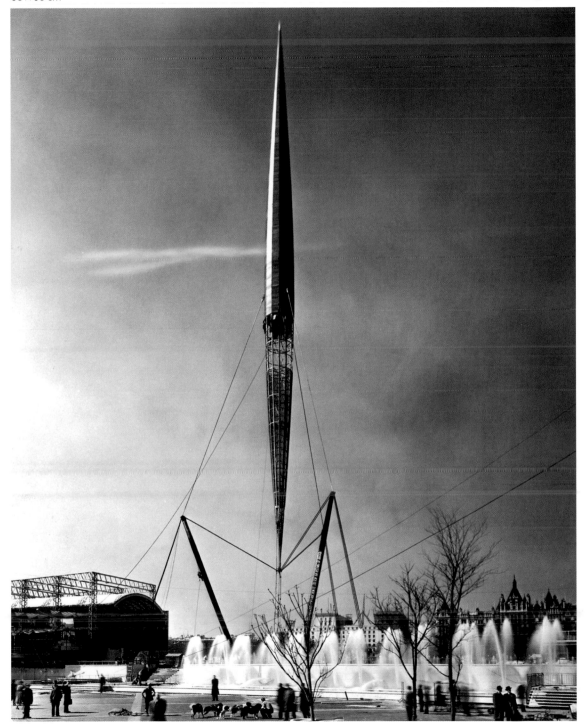

Edward Cullinan CBE RA
(Edward Cullinan Architects with Kevin Goh,
Nita Sharma and Frances Madders)
'Tiger Park' with Castleford Tigers
Pen
70 × 130 cm

Prof. Trevor Dannatt RA (Dannatt, Johnson Architects)
Two Houses – Initial Studies
Answood, Tisbury, Wilts.
(Trevor Dannatt RA)
Liss House, Richmond, Surrey
(David Johnson/Trevor Dannatt RA)
(Dannatt, Johnson Architects)
Mixed media
68 × 95 cm

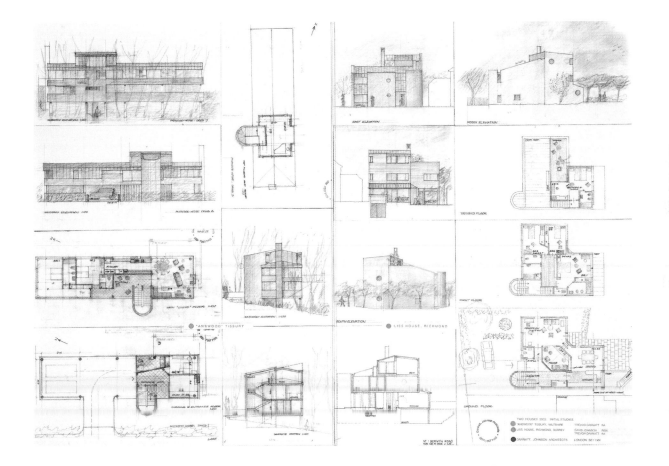

Gallery VIII

Since many sculptors responded to the invitation to submit drawings to this exhibition, there are fewer sculptures on display than usual, and most of them are displayed with paintings. 'Sculpture's always a challenge,' says John Wragg. (He and James Butler were responsible for selecting almost all of it this year.) 'We're normally allocated a room and otherwise have to persuade the painters to let us in.'

This year, however, one gallery – this one – is the result of several exceptions. It gives unusually generous space to sculptures and sculptors' drawings, and everything here has been selected and arranged by a single Member, Anish Kapoor. Kapoor has included one of his own sculptures, a large, immaculately made and highly polished object in blood-red acrylic.

He made it 'about seven years ago, when most of my pieces contrasted exterior and interior forms and had an interior volume. This one uses mirrored surfaces to collect space. In fact the long exterior curve here looks a bit like a pair of sunglasses reflecting everything around it.'

In the gallery, Kapoor has included 'objects that ambiguously hover between two and three dimensions. The Sol LeWitt, for example, is plainly a solid object. It exists in space but it nevertheless has many of the characteristics of a drawing. Dan Graham's *Pavilion* uses space to make space itself seem confusing. And Julian Opie's digital display of flashing yellow lights is actually static but creates the illusion of a woman in constant motion.'

Allen Jones's *Echo*, a maquette for one of his much larger painted-steel sculptures, also explores the territory between the two-dimensionally graphic and the three-dimensionally sculptural.

The drawings included here are also by sculptors. Kapoor himself contributes two gouaches, and there's a naturalistic drawing in pen and ink by Anthony Caro, something few visitors will have seen before. 'It's surprising how little like sculptors' work the drawings here look,' says Kapoor. 'Take the two by Barry Flanagan, for example. They're in outline only, not concerned with volume or texture at all.'

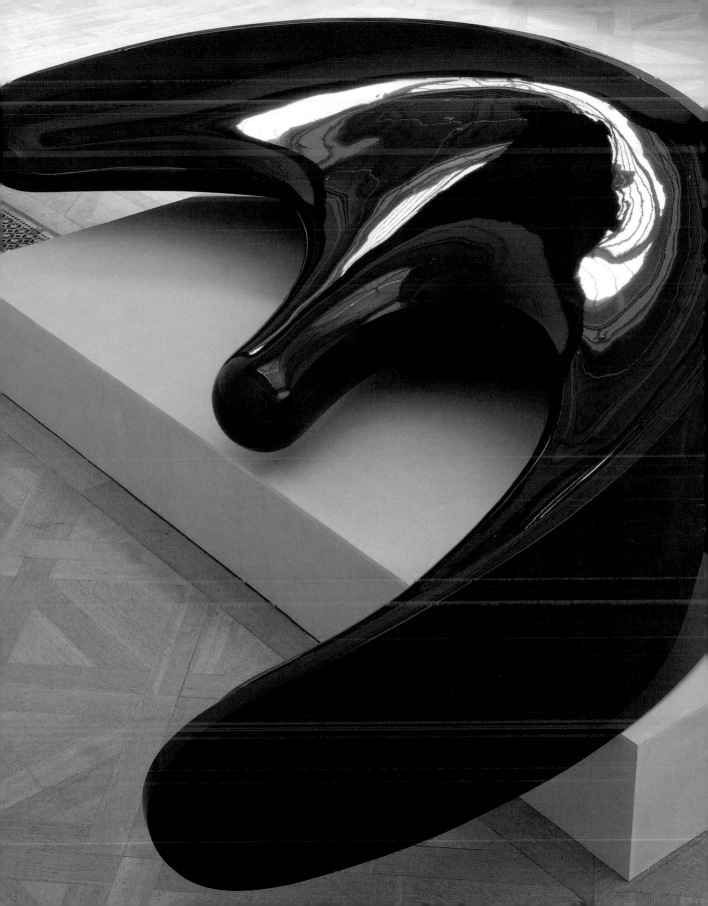

Alison Wilding RA
Wolf Series 7, 2003
Mixed media
42 × 52 cm

Rachel Whiteread
Drawing for a Floor Piece, 2002
Silver leaf
50 × 67 cm

Sol LeWitt
Open Geometric Structure 2, 1990
Wood
H 98 cm

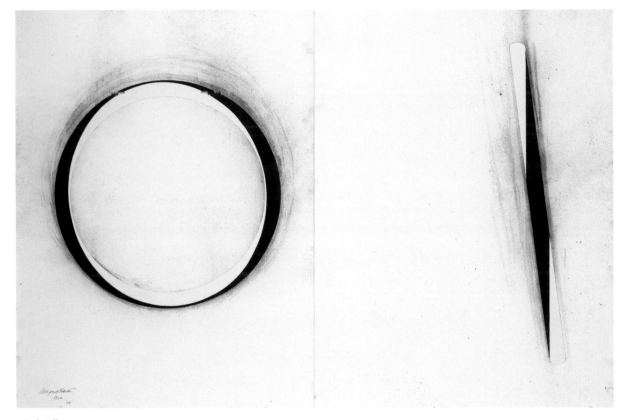

Nigel Hall RA
Drawing 1304
Gouache and charcoal
102 × 151 cm

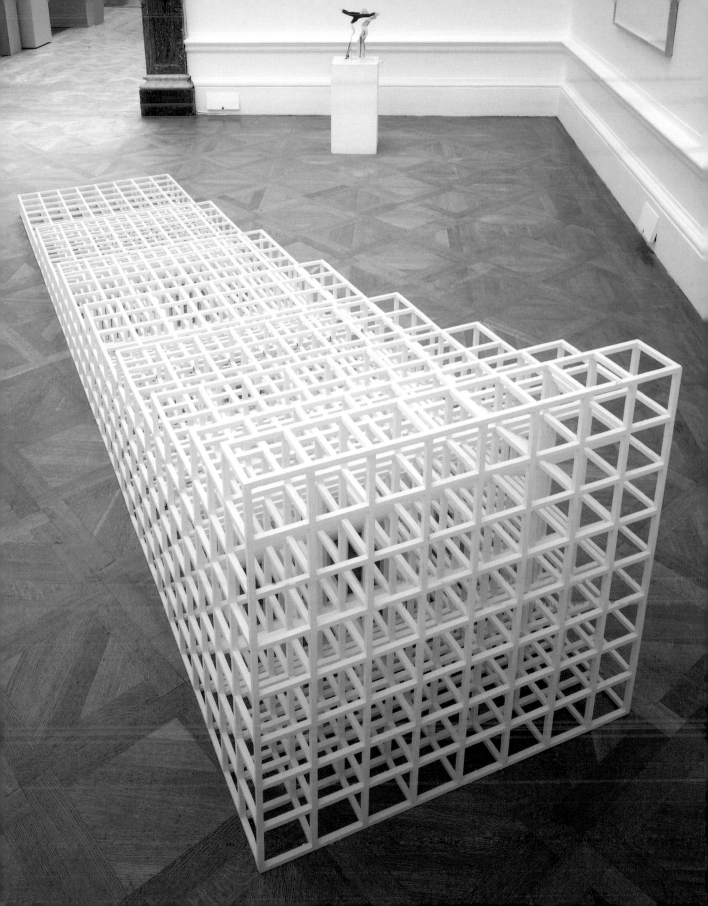

Barry Flanagan OBE RA
Diagram
Coloured markers
50 × 40 cm

Antony Gormley RA
Feeling Material X, 2003
Pigment
76 × 112 cm

This gallery of non-Members' work is dominated, at least when glimpsed at a distance from the Central Hall, by *Reverse*, the hugely magnified face of a girl by Jenny Saville. Another, quite different kind of naturalism is provided by Victor Newsome's meticulous *The Artist's Studio*, just purchased for Tate with funds from the Chantrey Bequest. (In 1841 the sculptor Sir Francis Chantrey left most of his considerable fortune for the purchase for the nation of works of art from the Summer Exhibition.) Although old, the bequest is not as ancient as Newsome's medium, egg tempera on board.

On the opposite wall is a bright, poster-like text painting by Peter Davies, who pays a double-edged tribute to Damien Hirst in the midst of a piece that is seemingly a graphic guide to the necessary components of success in the art world.

The generous, airy hang achieves a balance between works of quite different kinds. On the one hand, there are Paula Rego's ink-and-wash narratives – suggestive, ultimately unfathomable but seemingly taking place in an old people's home; on the other there's Dexter Dalwood's large and loosely painted *Grosvenor Square*.

Simon Periton's wreath-like paper cutout, *ADDI*, is like nothing else in the exhibition, while the two large watercolours by David Remfry impress because of their size and the way a notoriously difficult medium has been handled on this scale.

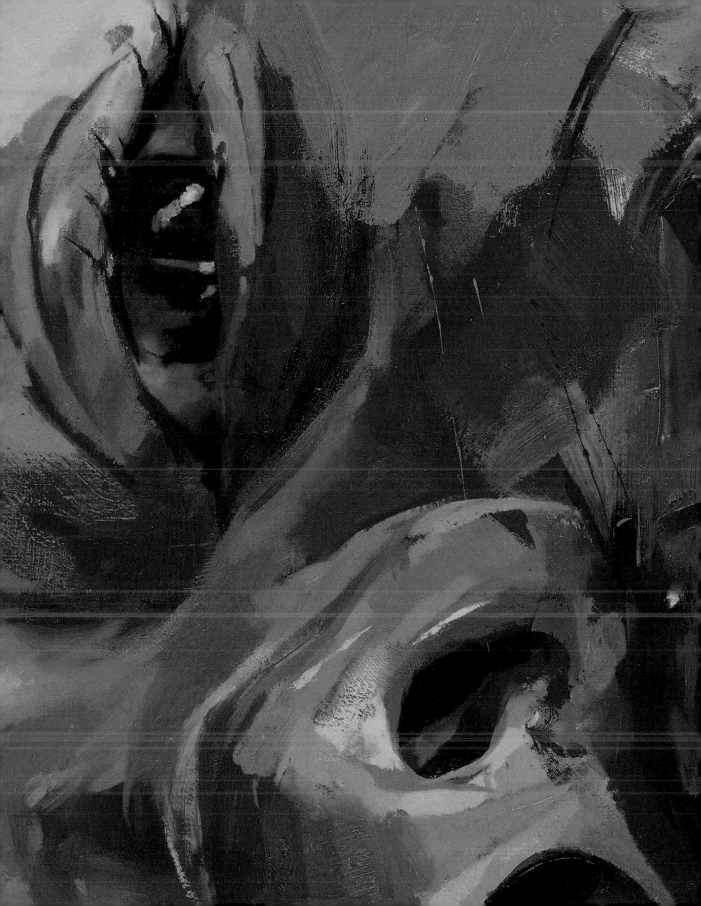

Jenny Saville
Reverse, 2003
Oil
213 × 244 cm

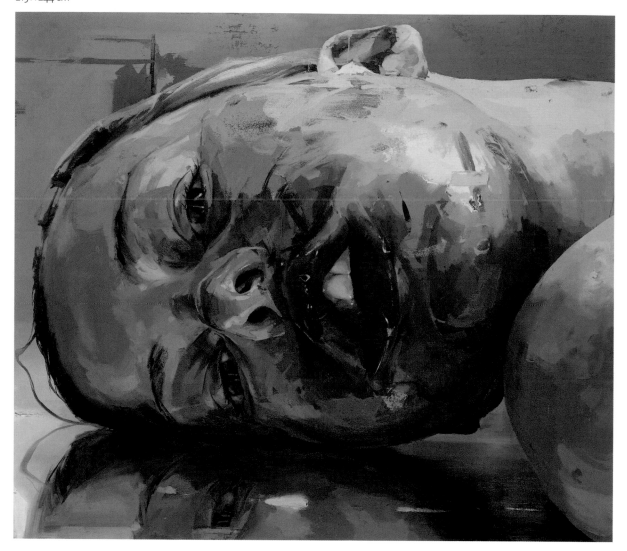

Peter Davies
Bigger than God – Damien Hirst Text Painting 2004
Acrylic
254 × 182 cm

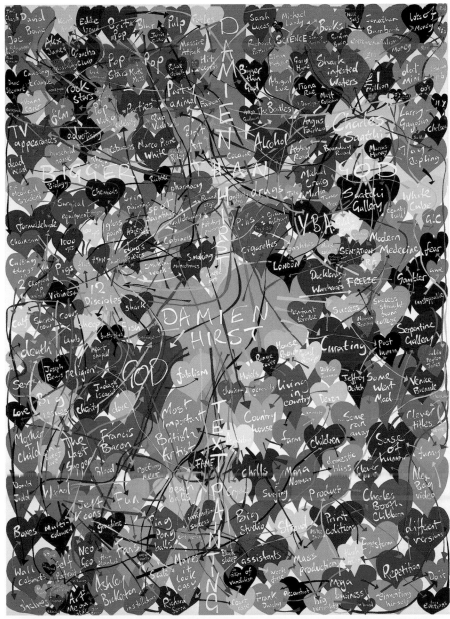

Dexter Dalwood
Grosvenor Square
Oil
268 × 347 cm

Prof. Sir Peter Blake CBE RA
Family
Bronze
H 58 cm

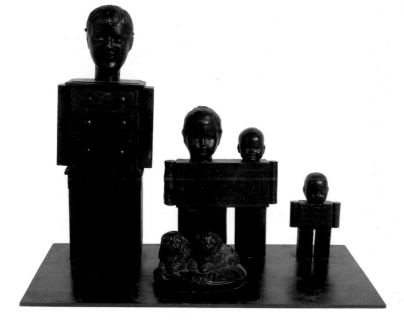

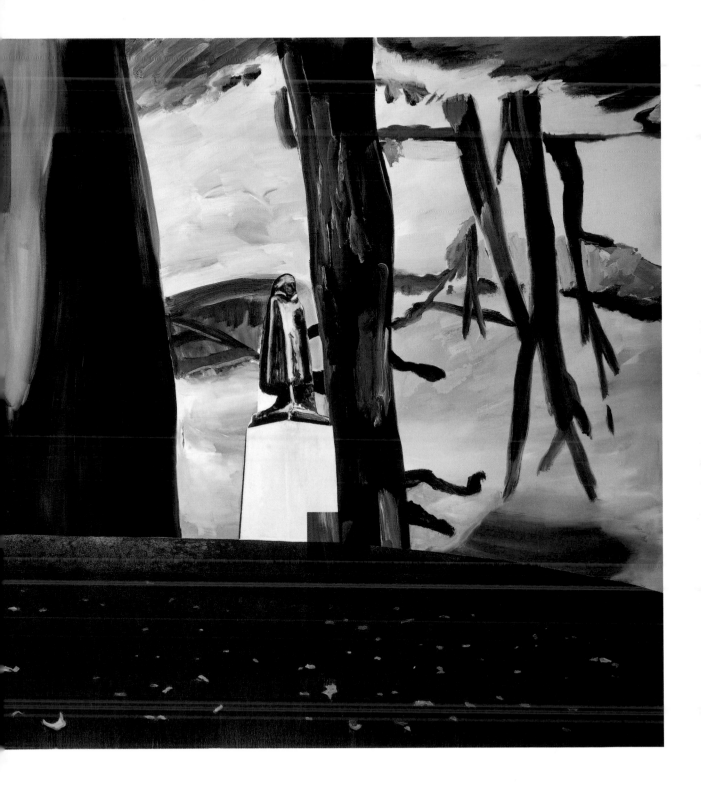

James Rielly
Y-fronts
Oil
274 × 365 cm

Lecture Room

Hung by Anthony Green and Maurice Cockrill, the Lecture Room is happily described by the former as 'a gallery in two halves' – meaning that he took responsibility for one side of the room while Cockrill supervised the other. Part of the gallery is dominated by Ivor Abrahams's huge owl made of epoxy resin and covered with collaged reproductions culled from magazines. 'It was very difficult to find a place for it,' confides Green, 'so I simply put it there. Painters usually take every opportunity to humiliate sculptors, but I think we've treated this bird rather well.' According to Cockrill, however, the owl is where it is because 'its eyes echo the spirals in John Mclean's abstract, *Zone 2003*, on the wall behind it, as well as the dominant forms in Sand Laurenson's *Seeing Stars*'.

Anthony Green is delighted by the unapologetically traditional look of much of this gallery. 'We've got Leslie Worth, one of England's greatest watercolourists, and Anthony Eyton, a tremendously accomplished artist who draws with the speed of thought. Attention should also be drawn to Henry Kondracki's *Traffic Lights*, and of course to Leonard Rosoman's glowing watercolours. Apart from Freddie Gore, who's 90, Leonard's the grand old man of the RA, in his 80s and still going strong. We've put Prince Charles's two watercolours of Lochnagar close to Rosoman so that HRH can feel that he's in first-class company.'

When hanging, Cockrill 'often tries to find pictorial rhymes that set up connections between various works'. It is, however, difficult to see what links the weirdness of Alix Soubrian-Hall's *Our Fabulous Babysitters* with William Tuck's gruesome, photographic close-up of a woman's battered head above it.

Most of the paintings in this gallery are figurative. One exception is Noel Forster's untitled arrangement of overlapping geometric systems. From high up, it commands attention.

Accommodating so many sculptures in so many different styles (from James Butler's monumental head of Jomo Kenyatta to Kerry Jameson's ceramic *Dog*) presented the hangers with an especially difficult challenge. They met it by positioning most of the sculptures in the centre of the gallery on plinths of varying heights, Kenyatta presiding at one end. A few sculptures are at a distance from this array, however. One of them is a rarity, a bronze by Peter Blake. It's *Snow White*, copied not directly from Disney but from Blake's own famous album cover for *Sergeant Pepper's Lonely Hearts Club Band*. Another of the sculptures – or painted reliefs – that stands apart from the centre is by Anthony Green himself. It's a self-portrait with a view of summer cornfields emerging like a beam from the artist's eyes. Paradise in Cambridgeshire.

Donald Hamilton Fraser RA
Coastal Landscape
Oil
46 × 58 cm

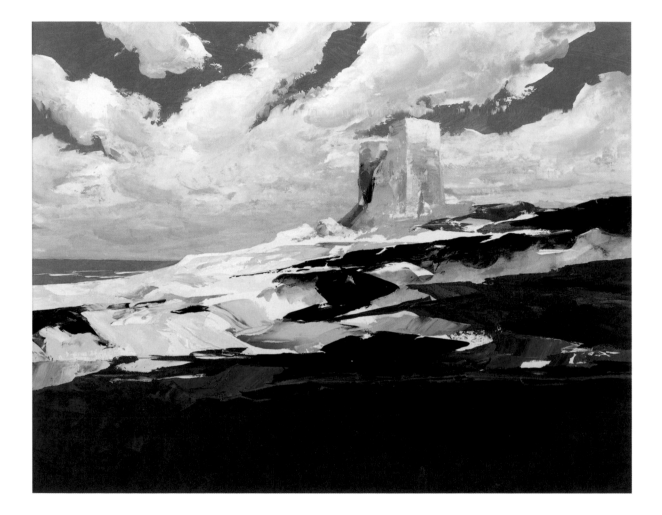

His Royal Highness The Prince of Wales
Lochnagar from Invermark
Watercolour
22 × 38 cm

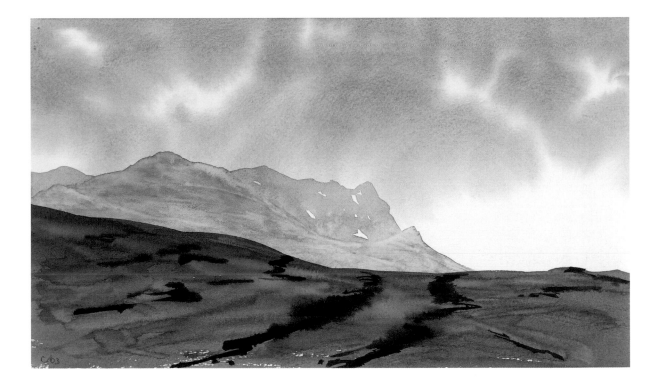

Leonard Rosoman OBE RA
Double Portrait of Lillian Browse
Acrylic
46 × 77 cm

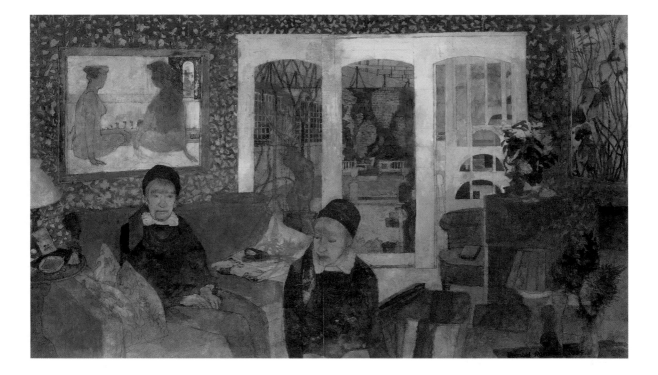

Prof. Norman Adams RA
Life Force
Watercolour
71 x 105 cm

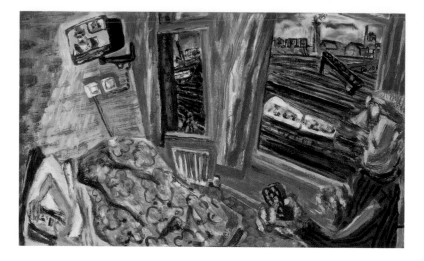

Timothy Hyman
On Waterloo Bridge
Oil
40 × 62 cm

Susie Hamilton
Hotel Dining Room
Acrylic
153 × 214 cm

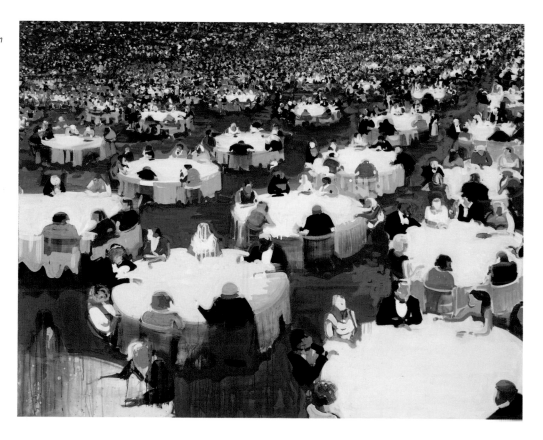

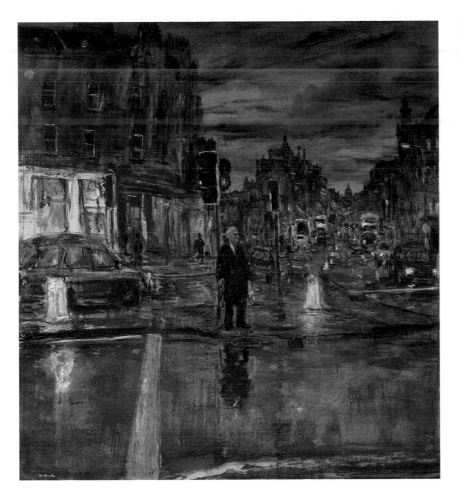

Henry Kondracki
Traffic Lights 2002
Acrylic
152 × 139 cm

Paul Becker
T.A.T.T. (Tired All the Time)
Oil
81 × 91 cm

Noel Forster
Not Titled, 2003
Oil on linen
182 × 152 cm

Jennifer Durrant RA
From a Series: Last Conversations
No.6
Acrylic and tempera
31 × 36 cm

John McLean
Zone 2003
Acrylic
143 × 84 cm

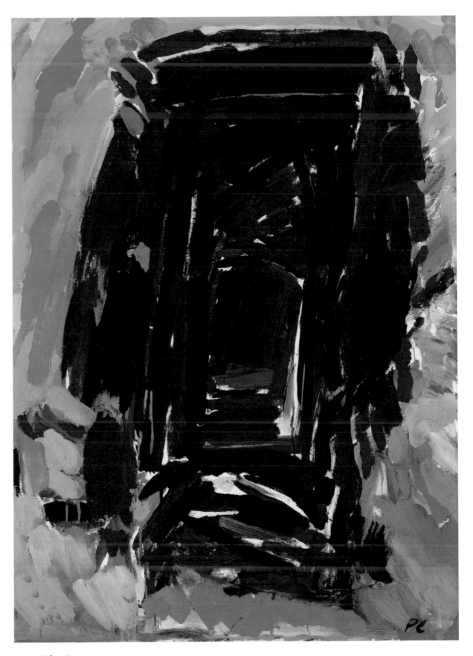

Peter Coker RA
Bamboo Pathway – Clos du Peyronnet, Garavan, Menton
Oil
95 × 60 cm

The much-travelled Richard Long, in whose work sculpture is combined with land art and elements related to conceptualism, is one of the most recently elected RAs. He's been asked to show his work in this prime space, and has chosen to use the walls to display in texts and photographs his records of walks in Britain and Japan, as well as a journey by canoe. The centre of the gallery, meanwhile, is reserved for a floor piece. This consists of two white crescents, one made 'with my hands using china clay from Cornwall', the other 'in white light projected from the ceiling. As people walk across the space, their shadows will break up the projected image.'

Long is perhaps best known for his text-based and photographic works that relate to solitary walks, some in extraordinarily remote and dramatic places. They record 'the traces he leaves on nature', sometimes with his hands, sometimes with his boots, sometimes by piling stones and rocks.

The idea behind *Transference*, one of the text-based pieces shown here, was to 'illustrate the parallels between nature in places far apart from each other. I first walked for five days on Dartmoor, recording some of the events and phenomena I observed there, and then I walked for five days on the other side of the world, in Japan. I was able to observe and list the same phenomena, showing something of the universality of nature.'

'All my work is about leaving a trace on nature,' he adds. 'Sometimes nature makes the image for me, sometimes I do. The white crescents are about two kinds of trace.'

TREADING STONES

WALKING IN A DIFFERENT DIRECTION EACH DAY FOR FIFTEEN DAYS

CAMPING FOR FOURTEEN NIGHTS AT A BOREHOLE ON GUARRIE BERG IN THE KAROO

SOUTH AFRICA SUMMER 2004

I HEAR THAT LONESOME WHISTLE BLOW
SIX DAYS BY KAYAK DOWN THE COLUMBIA RIVER
FROM FRESH WATER TO SALT WATER WITH BARGES AND STEAMBOATS
BELOW HONKING GEESE BETWEEN FREIGHT TRAINS AND ROAD TRAFFIC
FROM GRASSLAND TO FOREST UNDER THREE BRIDGES
SLEEPING ON THREE ISLANDS AROUND TWO DAMS
PAST FLOODMARK LINES OVER FISHING NETS
WATCHING THE RIVER FLOW

Gallery X

Though consisting almost entirely of work by non-Members, this gallery, the final room in the exhibition, does contain work by painters whose work features regularly in Summer Exhibitions. At least three of them belong to what Maurice Cockrill (who hung the space) calls the 'School of Tunbridge Wells'. This is the not entirely straight-faced description of Roy Oxlade, his wife Rose Wylie, and Georgia Hayes, whom Oxlade used to teach. All paint loosely and dashingly, and as Hayes's *Bride Waiting* shows, employ imagery that verges on the childlike. All exploit the properties of paint itself, which is largely why their work appears in this gallery. 'I like almost everything here precisely because it's about the act of painting itself,' says Cockrill.

You can see what he means, in the paintings by Richard Smith, Gary Wragg and Lucy Jones, whose sense of colour is, as always, impressive. Painterly in a different way is *Agony in the Garden* by Sheila Girling. As Cockrill observes, 'It looks abstract at first sight, but quickly resolves itself into a landscape with figures, Christ praying in the centre.'

Finally, look out for a very small Gillian Ayres, hung to the left of the door into the gallery. By comparison with most of her work, it's tiny, but still has enormous punch.

Dr Basil Beattie CBE
Playing Up
Oil and wax
213 × 198 cm

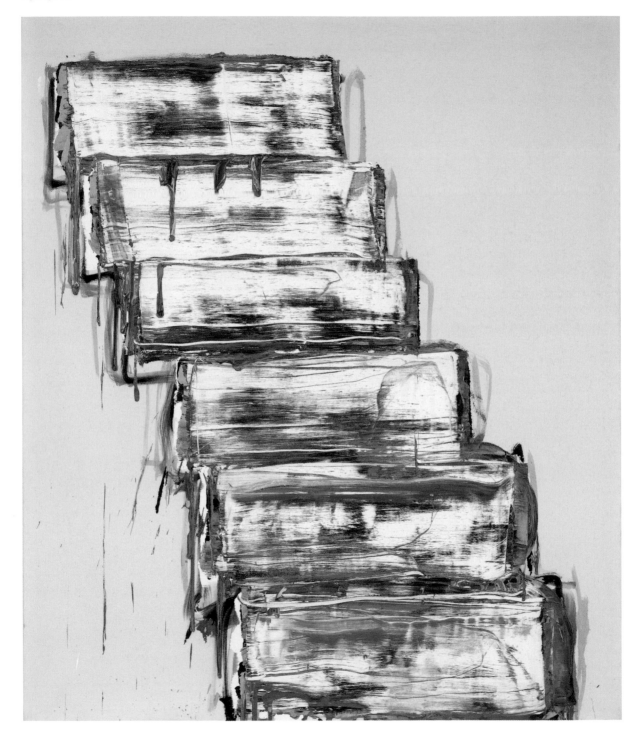

John Potter
Flavours
Mixed media
152 × 152 cm

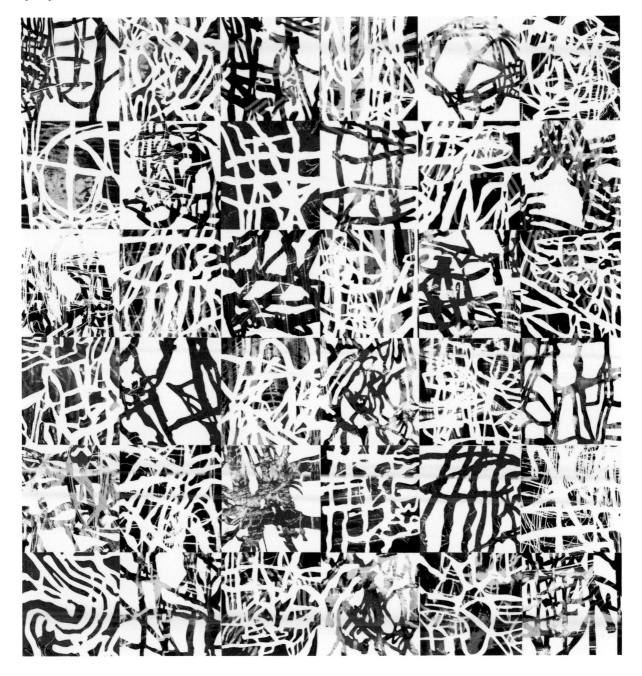

Raymond Yap
Red Gestalt
Gloss paint
91 × 61 cm

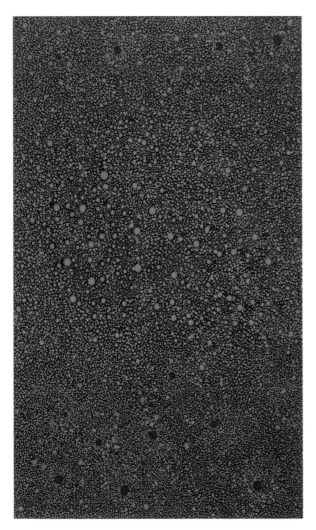

Tom McRae
Chapel
Oil
29 × 13 cm

Patrick Brandon
Ahab Reflects
Mixed media
76 × 106 cm

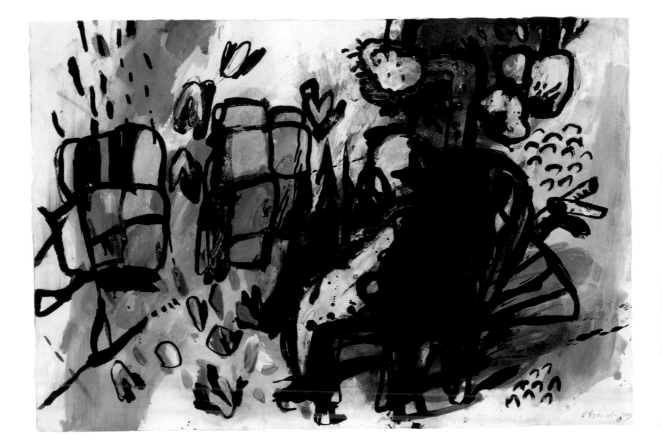

Nikola Ritterman Savic
Anruf für Zwei (2)
Acrylic
165 × 165 cm

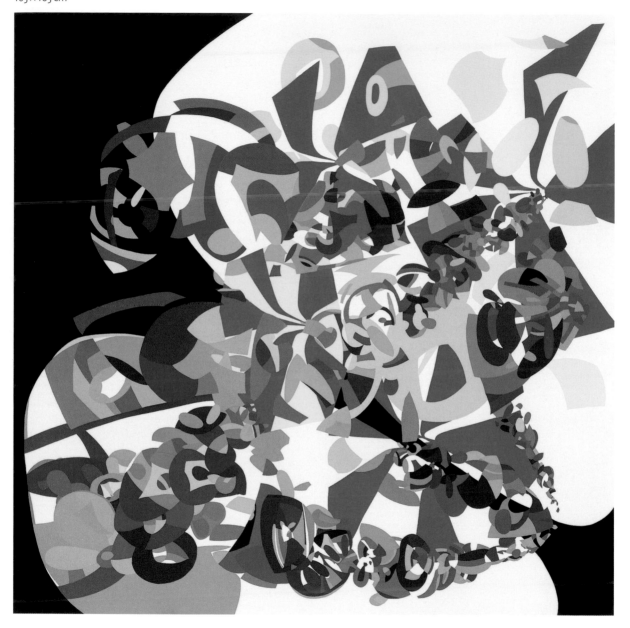

Julie Neat
Untitled a
Oil
203 × 107 cm

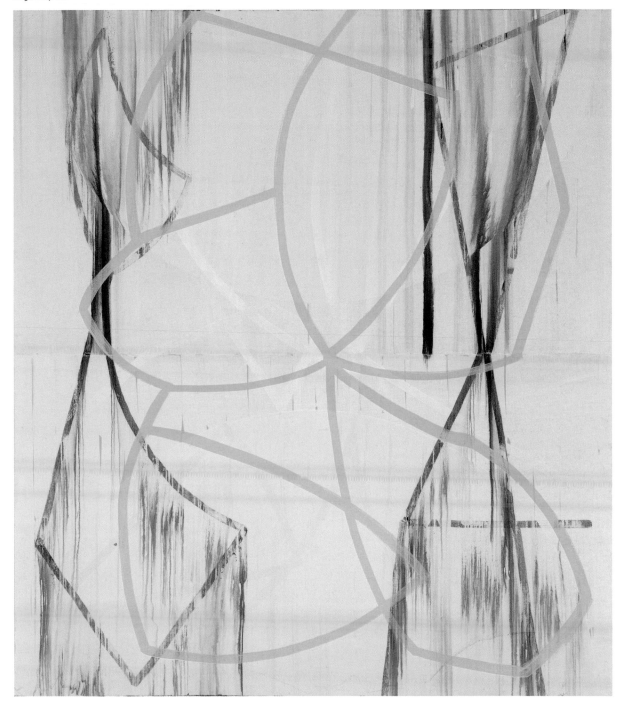

Index

Royal Academy of Arts in London, 2004

Royal Academy Trust

Registered charity number 1067270

The Royal Academy of Arts, Registered Charity number 212798, is Britain's founding society for promoting the creation and appreciation of the visual arts through exhibitions, education and debate. Independently led by eminent artists and architects, the Royal Academy receives no annual funding via the government, and is entirely reliant on self-generated income and charitable support.

You and/or your company can support the Royal Academy of Arts in a number of different ways:

- £57 million has been raised for capital projects, including the Jill and Arthur M Sackler Wing, the restoration of the Main Galleries, the restoration of the John Madejski Fine Rooms, and the provision of better facilities for the display and enjoyment of the Academy's own Collections of important works of art and documents charting the history of British art.
- Donations from individuals, trusts, companies and foundations also help support the Academy's internationally renowned exhibition programme, the conservation of the Collections and educational projects for schools, families and people with special needs; as well as providing scholarships and bursaries for postgraduate art students in the RA Schools.
- Companies invest in the Royal Academy through arts sponsorship, corporate membership and corporate entertaining, with specific opportunities that relate to your budgets and marketing/entertaining objectives.

- A legacy is perhaps the most personal way to make a lasting contribution, through the Trust endowment fund, ensuring that the enjoyment you have derived is guaranteed for future generations.

To find out ways in which individuals, trusts and foundations can support this work (or a specific aspect), please contact Brendan Kramp on 020 7300 5637 to discuss your personal interests and wishes.

To explore ways in which companies can be come involved in the work of the Academy to mutual benefit, please telephone Jane Marriott on 020 7300 5665.

To discuss leaving a legacy to the Royal Academy of Arts, please telephone Sally Jones 020 7300 5677.

Membership of the Friends

Registered charity number 272926

The Friends of the Royal Academy was founded in 1977 to support and promote the work of the Royal Academy. It is now one of the largest such organisations in the world, with around 87,000 members.

As a Friend you enjoy free entry to every RA exhibition and much more...

- Visit exhibitions as often as you like, bypassing ticket queues
- Bring an adult guest and four family children, all free

- See exhibitions first at previews
- Keep up to date through RA Magazines
- Have access to the Friends Rooms

Why not join today

- Onsite at the Friends desk in the Front Hall
- Online on www.royalacademy.org.uk
- Ring 020 7300 5664 any day of the week

Support the foremost UK organisation for promoting the visual arts and architecture – which receives no regular government funding. *Please also ask about Gift Aid.*

Summer Exhibition Organisers
Lucy Andersen
Chris Cook
Edith Devaney
Katherine Oliver
Harriet Sawbridge

Royal Academy Publications
David Breuer
Harry Burden
Carola Krueger
Peter Sawbridge
Nick Tite

Book design: 01.02
Photography: FXP and John Riddy
Colour reproduction:
DawkinsColour
Printed in Italy

British Library
Cataloguing-in-publication Data
A catalogue record for this book is
available in the British Library

ISBN 1-903973-48-1

Illustrations
Page 2: Anthony Whishaw RA,
 Maelstrom (detail)
Page 4: Sandra Blow RA,
 Demi Semi Quaver (detail)
Page 6: Frank Auerbach,
 Head of David Landau (detail)
Page 8: The late Lynn Chadwick RA,
 Stretching Beast I 1990
Page 9: Ian McKeever RA,
 Filament III (detail)
Page 11: The late Colin Hayes RA,
 *Landscape. W. Crete
 Towards the Rialto, Venice
 Valley in Tenerife
 Above Puerto de la Cruz, Tenerife
 The Potala, Tibet
 Southern Evvia, Greece*
Page 23: Prof. John Hoyland RA,
 The Golden Traveller 21.3.2004
 (detail)
Pages 26/27: The late Sir Terry Frost
 *Installation, Contrasts in Red,
 Black and White*;
 right: *Spring*
Page 31: Mary Norman,
 Valentine: Barred Wyandotte
 (detail)
Page 51: Charles Hardaker,
 Opening Door (detail)
Page 65: Frederick Gore RA,
 Rush Hour, 3rd Avenue (detail)
Page 81: Anselm Kiefer Hon RA,
 Der Universalien Streit (detail)
Page 95: Angus Fairhurst,
 *This Does Not Last More Than
 Ten Seconds (x10), 2001* (detail)
Page 111: Leonard McComb RA,
 *Portrait of Pippa Wylde –
 Star Dancer Royal Ballet* (detail)
Page 133: Lord Foster of
 Thames Bank OM RA,
 (Foster and Partners),
 Millau Viaduct, France
Page 149: Anish Kapoor CBE RA,
 Turned into the Interior II, 1998
Page 157: Jenny Saville,
 Reverse (detail)
Page 165: Susie Hamilton,
 Hotel Dining Room (detail)
Page 177: Richard Long RA,
 Treading Stones
Page 178/179: Richard Long RA,
 *I Hear That Lonesome
 Whistle Blow*
Page 181: Tom McRae,
 Chapel (detail)